MW00613049

IMAGES
of America

NOVI

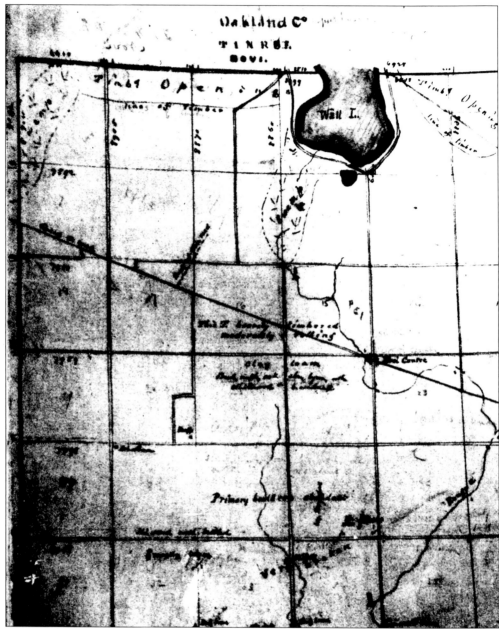

This map of Novi dates from 1839–40. It was one of a series of maps authorized by the state of Michigan, and prepared under the direction of Douglass Houghton, state geologist. However, they were principally the work of Bela Hubbard, assistant geologist, and others. (Courtesy Burton Historical Collection of the Detroit Public Library.)

IMAGES
of America

NOVI

Barbara G. Louie
with Samuel D. Popkin

ARCADIA
PUBLISHING

Copyright © 1998 by Barbara G. Louie with Samuel D. Popkin
ISBN 978-0-7385-0012-6

Published by Arcadia Publishing
Charleston, South Carolina

Printed in the United States of America

Library of Congress Catalog Card Number: 9887869

For all general information contact Arcadia Publishing at:
Telephone 843-853-2070
Fax 843-853-0044
E-mail sales@arcadiapublishing.com
For customer service and orders:
Toll-Free 1-888-313-2665

Visit us on the Internet at www.arcadiapublishing.com

Dedicated to Ming and to Roz.

CONTENTS

ACKNOWLEDGMENTS

Many thanks go to Lou Martin, Public Information Director, City of Novi, for his generosity and enthusiasm in providing most of the historical photos of Novi to be used in this book. The cooperation of Northville Historical Society's Archivist, Sandra Basse, is also appreciated.

This book could not have been done without the professional assistance of my father, Sam Popkin, and the help of my mother, Rosalind Popkin, and, of course, my husband, Ming.

All photographs are courtesy of the City of Novi, except where indicated. Samuel D. Popkin was the photographer of all but a few of the modern-day photographs. Other images, as indicated, were taken by Michael Everett.

The information on the Walled Lake Casino and Amusement Park was obtained from the video, "Walled Lake Casino," produced by the City of Novi.

INTRODUCTION

Novi, Michigan was first settled in 1825, one month before the opening of the Erie Canal. Novi was a swampy, wooded marshland, but the urge to settle the untamed west was strong, and little by little, more people came. The opening of the Erie Canal in May of 1825 provided the impetus for Easterners to travel west, and thousands poured into Michigan and other western states. Travel time between New York and Michigan had been cut down from over one month to just a few days, and to many, the move to pioneer country was irresistible.

By the time statehood was granted in 1837, Michigan's population had soared to nearly 200,000 from under 5,000 just two decades earlier.

Novi, located about 30 miles northwest of Detroit, proved to have enough good farmland to attract a number of people, and most of the early settlers were farmers. Gradually, a few businesses developed, and by 1830 a small town had risen. Located at what is today the intersection of Novi Road and Grand River, Novi's "Four Corners" was the center of the business district for many years.

The sleepy, peaceful farm community lasted for over a century. But Novi's location along Grand River Road did not allow it to remain stagnant. In the 1950s, construction began on a freeway that would parallel Grand River from the bustling metropolis of Detroit to the state capital in Lansing. The freeway would cut directly through Novi, and the look of the town would forever be changed.

The freeway connected Novi to the outside world in a fast and easy way, and developers soon saw the opportunities available in the empty spaces that once catered to wooded forests and open meadows.

The speed of the traffic on the freeways soon became symbolic for the sudden growth occurring in Novi. Housing developments began to spurt up all over town, and Novi's population climbed. The rapid rate of construction frightened a number of local residents, threatening their previously tranquil way of life. During the next 20 years Novi was cited as one of the fastest-growing communities in the nation. Though a number of local residents still mourn the loss of their old lifestyle, more continue to arrive to take advantage of the ever-changing city.

In the 1970s, the first major shopping mall was built, and the construction has not stopped since.

Many of the old, quaint farmhouses and rural stores are gone, but if one looks hard enough, much of Novi's past still lingers. Today, the growth of Novi is evident everywhere, in its new subdivisions, shopping malls, churches, and businesses. This book is an attempt to show where

Novi has been and the direction it is heading. Through comparisons of photographs from then and now, one can see how Novi has survived from a rural farming community to a thriving commercial suburb.

One

EIGHT MILE ROAD
NOVI'S SOUTHERN BORDER

Novi's southern boundary begins at Eight Mile—or Base Line—Road. In 1815, when Michigan was still part of the Northwest Territory, surveyors designated a base line that ran east and west across Michigan. This line was created in order to establish a principal meridian for the territory. From this line, all the townships in Michigan were created during the early 1800s.

In Detroit, roads marking the distance from the Detroit River heading north were given mileage designations. Thus, Base Line Road is also known as Eight Mile Road and indicates that it lies approximately 8 miles from the river, as the crow flies.

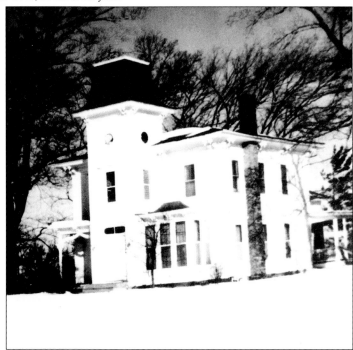

Cousins William Yerkes and Thomas Pinkerton were among Novi's first settlers, arriving from New York in 1825. Their family soon joined them. William's father, Joseph, located his farm along Base Line Road. About the time this photo was taken, in 1987, the house was listed on local, state, and national historical site registers as one of the oldest houses in Novi. (Courtesy Northville Historical Society.)

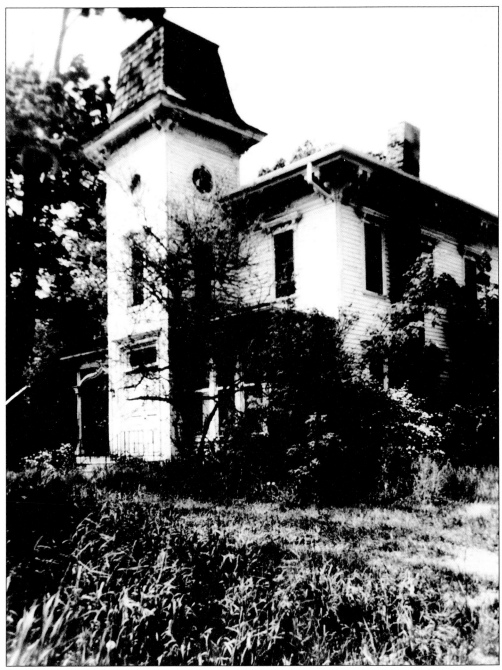

The last owner of the Yerkes house, Patricia Hann, had received approval to convert the house into professional offices, but the house became the victim of an arson attack, and burned to the ground in August 1989. This photo of the abandoned home was taken shortly before its destruction. (Courtesy Novi Public Library.)

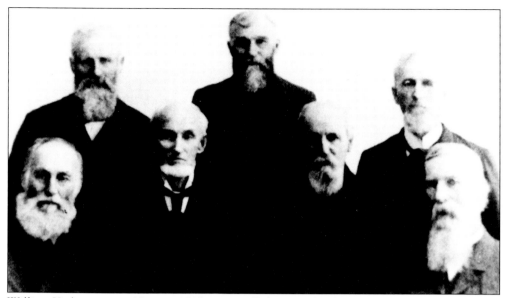

William Yerkes came to Novi in 1825, eventually bringing his family from New York with him. This 1890 photograph pictures his sons as follows: (front row) Silas, Joseph Dennis, William Purdy, and Robert; (top row) Charles, George, and Harrison. All but Joseph and William were born in Novi.

VOTE FOR

EDMUND P. YERKES

for

SUPERVISOR

TOWNSHIP OF NOVI

PRIMARY ELECTION, FEB. 16, 1953
—REPUBLICAN—

Edmund Yerkes, a Northville/Novi attorney, lived in the family home on Eight Mile Road until the late 1950s, when he moved into the city of Northville. The home stood on the Northville-Novi border.

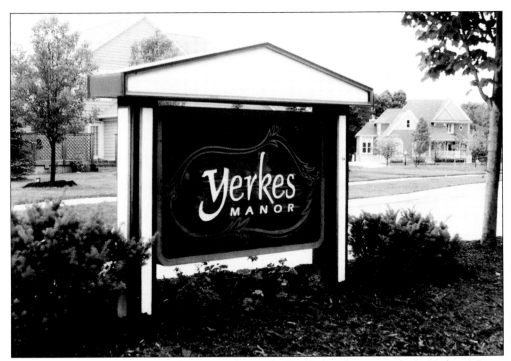

Located on the same site as the original Joseph D. Yerkes house, today's Yerkes Manor Subdivision honors the memory of the early settlers.

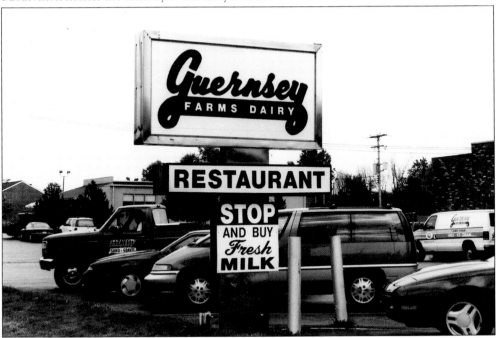

This view, located on Novi Road just north of Eight Mile Road, is one of Novi's most refreshing spots. Guernsey Farms Dairy has been a local landmark since 1945, and gained national recognition when People Magazine rated its butter pecan ice cream the best in the country in 1984.

Two

NINE MILE ROAD
NOVI'S RICH FARMLAND

Many of the earliest farms in Novi were located along both sides of Nine Mile Road. Even today, the road retains a pleasant, mostly residential look.

When the citizens of Novi Township voted to become a city in 1969, one group of residents resisted. As a result, Novi Township today consists of only 150 residents and one subdivision. The township is located between Nine and Ten Mile Roads, off Novi Road.

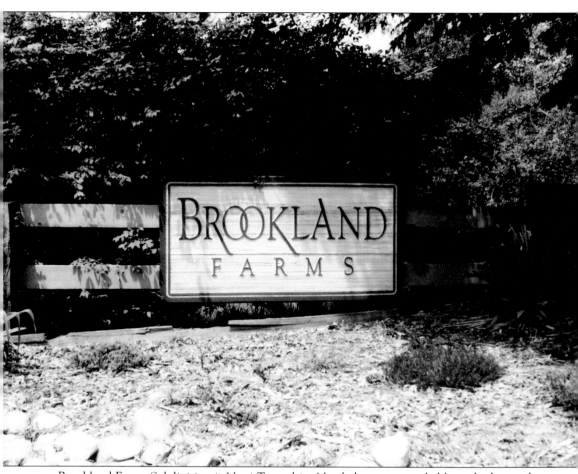

Brookland Farms Subdivision is Novi Township. Nestled among wooded lots, the homes here enjoy slightly more privacy than their city neighbors.

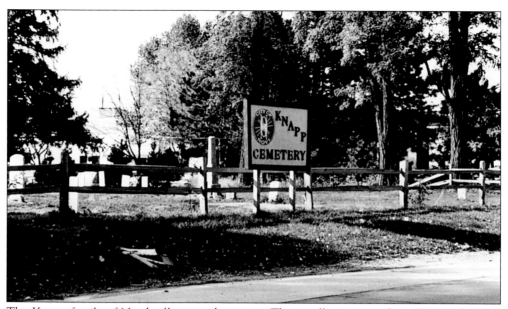

The Knapp family of Northville was a large one. This small cemetery along Nine Mile Road and bearing the family name is located in Novi. As early residents of the area, the Knapps were active in civic and church affairs.

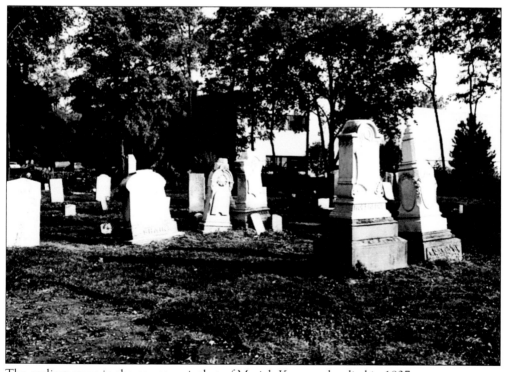

The earliest grave in the cemetery is that of Mariah Knapp, who died in 1837.

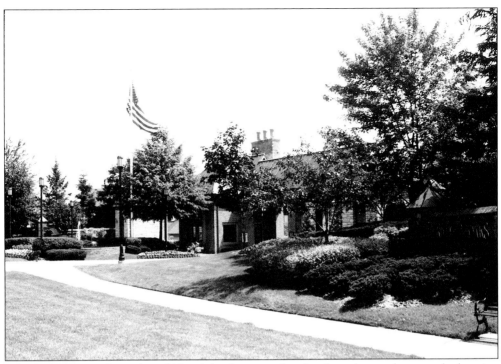

Where at one time farms dotted Novi's landscape, today they have been taken over by housing developments, such as this apartment complex located on Novi Road, north of Nine Mile.

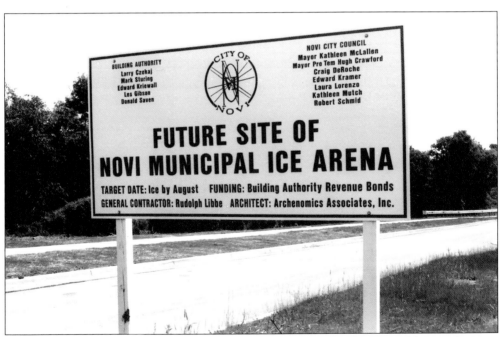

Growth in Novi includes sports and recreation as well as urban development. After much recent debate, an ice arena was recently given the go-ahead. It will be built along Novi Road, north of Nine Mile.

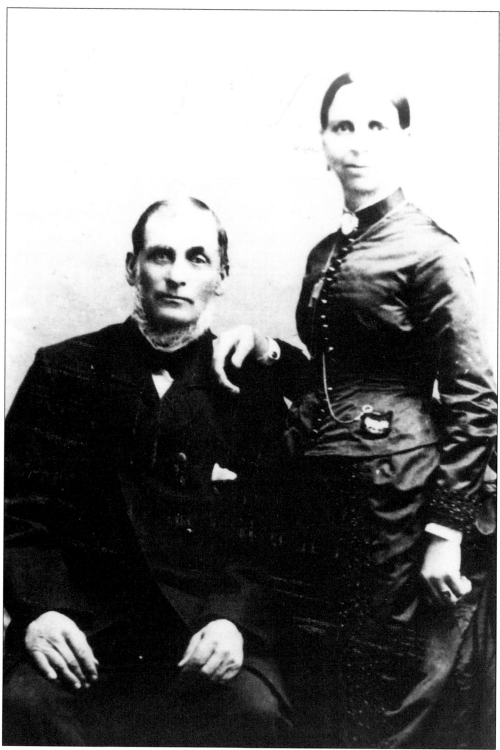

Andrew and Laura Welsh, pictured here on their wedding day, had a large farm along Nine Mile Road in the mid-1800s.

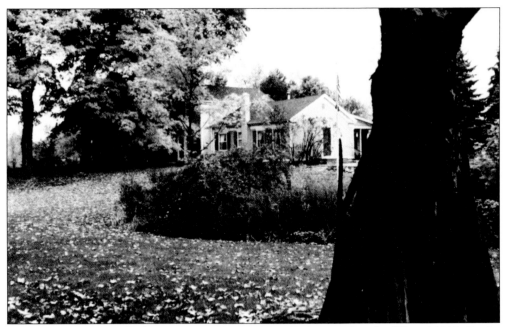

Samuel White, originally from Niagara County, New York, served in the War of 1812. By the time of his discharge from the Army in 1826, with a rank of lieutenant colonel, White moved with his family to Michigan. They settled in Novi, building this house on Nine Mile Road west of Taft Road, around 1840.

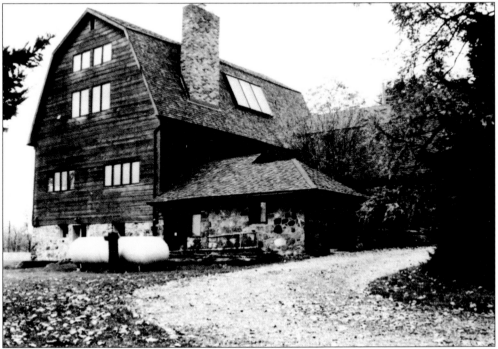

The Samuel White barn was part of a working farm for well over one hundred years before being converted into a house in 1980. The house and barn stood together on a number of acres of land into the 1990s, when a subdivision was built around it.

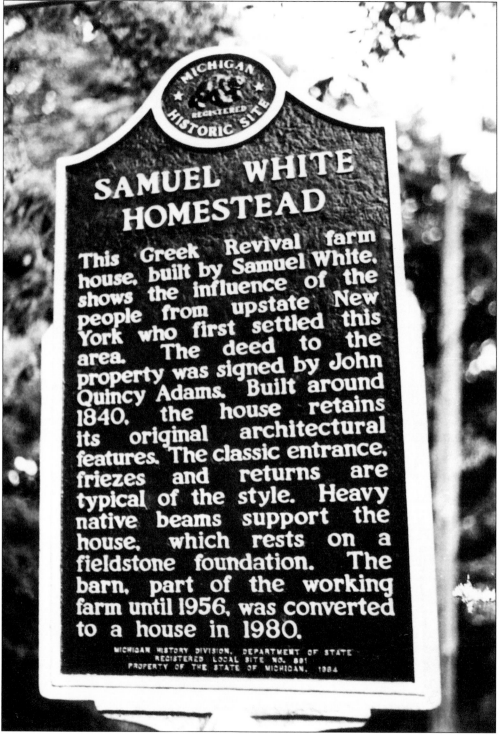

SAMUEL WHITE HOMESTEAD

This Greek Revival farm house, built by Samuel White, shows the influence of the people from upstate New York who first settled this area. The deed to the property was signed by John Quincy Adams. Built around 1840, the house retains its original architectural features. The classic entrance, friezes and returns are typical of the style. Heavy native beams support the house, which rests on a fieldstone foundation. The barn, part of the working farm until 1956, was converted to a house in 1980.

MICHIGAN HISTORY DIVISION, DEPARTMENT OF STATE
REGISTERED LOCAL SITE NO. 891
PROPERTY OF THE STATE OF MICHIGAN. 1984

This historic plaque notes the Samuel White Farm as a registered historic site, one of several in the Novi area. (Everett.)

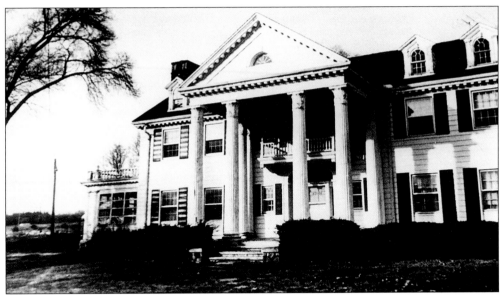

Located east of Novi Road on Nine Mile is the imposing Rogers Mansion. Here, as seen in 1975, it was first proposed as a fine dining restaurant and later turned into the White House Manor Restaurant.

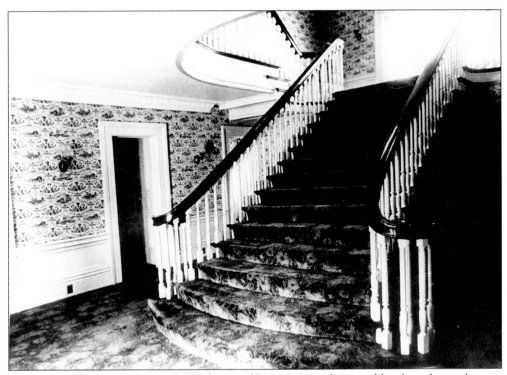

The grand staircase was designed with hopes of Rogers seeing his granddaughter descend it as a bride. His hopes were shattered when she eloped. Instead of the Rogers wedding, the staircase has since witnessed the tread of countless feet marching up and down to private rooms of the restaurant that the building would eventually become.

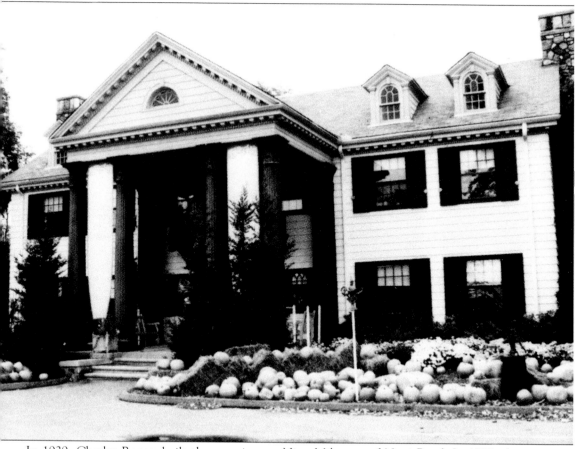

In 1929, Charles Rogers built the mansion on Nine Mile east of Novi Road. In 1992, the building was sold to new owners and turned into Home Sweet Home Restaurant. It currently sits empty.

The Heslip Farm was a working farm until the end of the 1960s. Run by Robert and Arthur Heslip through the 1950s, and by Richard Heslip in the 1960s, the farm was located on Nine Mile Road.

The Cotter Farm, where City of Novi's Special Recreation Coordinator Kathy Crawford grew up, was located along Grand River. It covered about 300 acres and operated through the 1950s. The building to the far left is the former Whitehall Convalescent Center.

Three

TEN MILE ROAD
WHERE THE ACTION IS

When the Novi Public Library and Novi Police Department built their new buildings in 1976–77 along Ten Mile Road, the focus of the city moved with them. City offices were located in half of the new library building, which was built on the land of the Fuerst family farm.

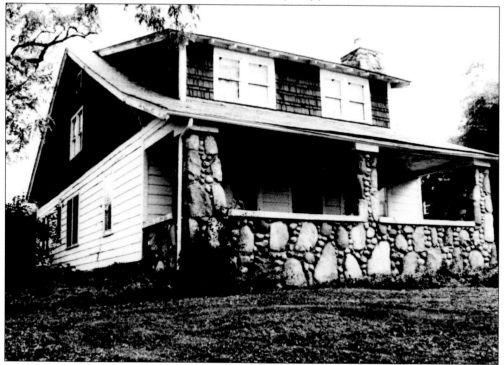

In 1917, Jacob and Bessie Fuerst brought their large family from Highland Park to Novi. Their hilltop home at Taft Road and Ten Mile remained in the family. Daughters Iva and Ruby lived in the house until their deaths in 1991.

The Fuerst estate and orchards once covered the area now used by the Novi Public Library, Civic Center, Police Department, and High School.

The Novi Public Library began in 1960 in a former bank building on Novi Road. The library moved to its own structure in 1977, where it shared half its space with the city offices for the next ten years.

The modern Novi Civic Center was constructed in 1987, and for the first time in Novi's history, was able to accommodate all its city departments under one roof.

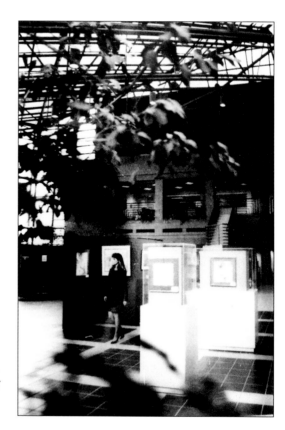

The lobby of the Novi Civic Center, with its glass-topped atrium, features constantly changing exhibits, usually focusing on local artists.

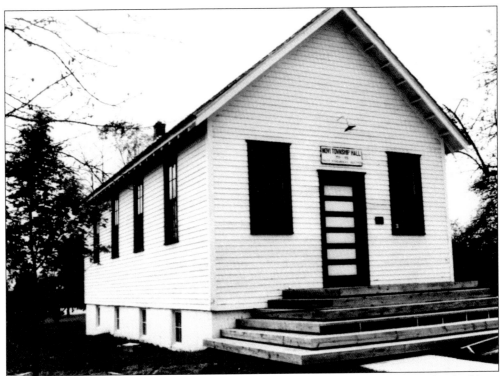

The Novi Town Hall was built in 1914 after a lightning storm destroyed an earlier building, along with the Novi Baptist Church. This photo was taken shortly after its relocation to the grounds of the Novi Public Library in 1986.

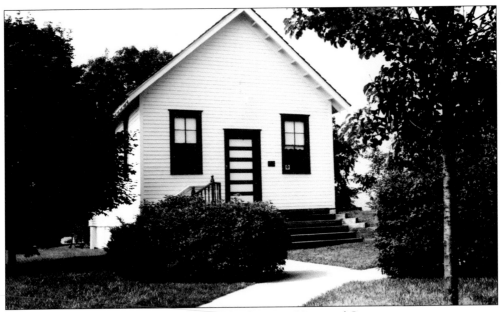

The township hall today acts as a museum for the Novi Historical Society.

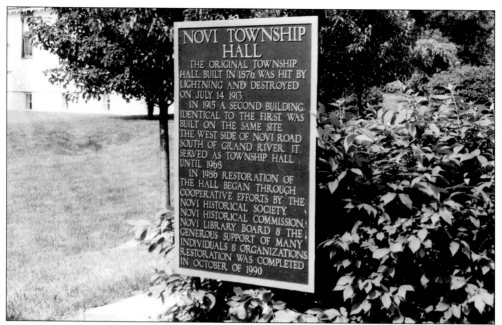

The Town Hall Museum was dedicated in 1989.

Novi High School was also added to the new complex near Ten Mile and Taft Roads in 1977, on land situated directly behind the public library. Additions to the school were made in the 1990s.

Novi High School's Marching Band is pictured here in a Memorial Day parade in the 1950s.

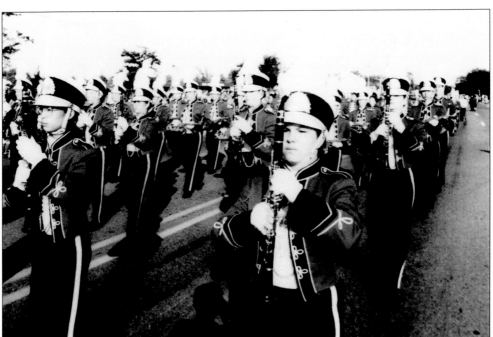

Novi's marching band has changed its look over the years, transforming from a neatly dressed group of youngsters to a smartly uniformed precision team.

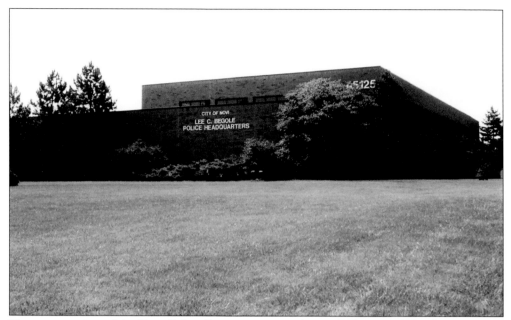

The construction of the Novi Police Department complex took place in 1977, when it moved from its former location near the old library on Novi Road. The new Police Department remained near the library, settling just east of the new building on Ten Mile Road. With all three facilities—the library, city hall, and police department—in the same area, focus was taken away from the former "Novi Corners" for the first time since 1830.

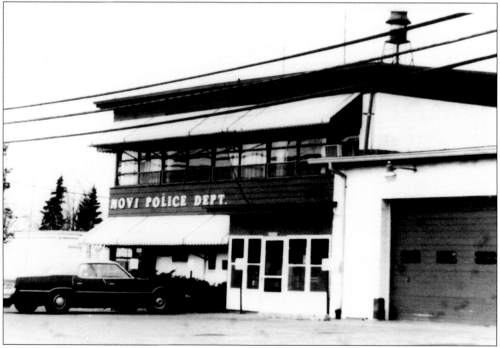

Prior to 1954, Novi Township had to rely on the Oakland County Sheriff's Department for police protection. Then, on October 1, 1954, the Novi Police Department was formed.

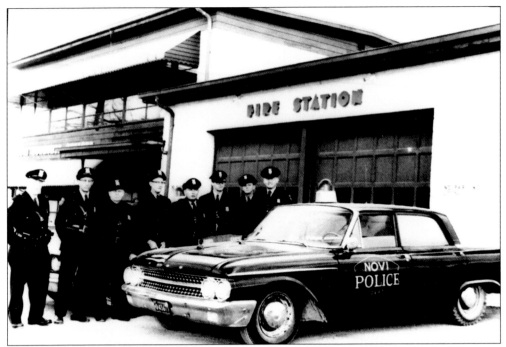

With the purchase of an REO fire truck in 1929, a fire department was established in Novi. The truck was used until 1946, when it was replaced by a Chevrolet truck with a 350-gallon water tank. The Police/Fire Department was originally located on Novi Road. The police force is pictured here in 1958.

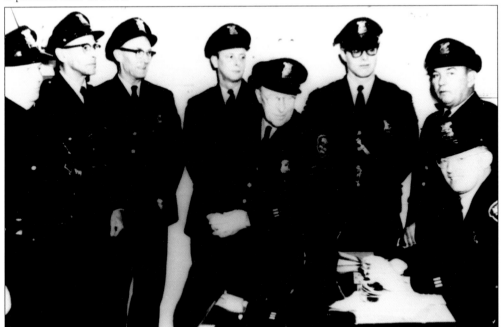

With two radio-equipped cars, the original Novi Police Department consisted of Chief Lee BeGole and Officers Young, Leoffler, and Noble. Pictured here is the growing staff of the department in 1959. Chief BeGole is seated at right.

The early Nove Police Department also had an emergency rescue vehicle.

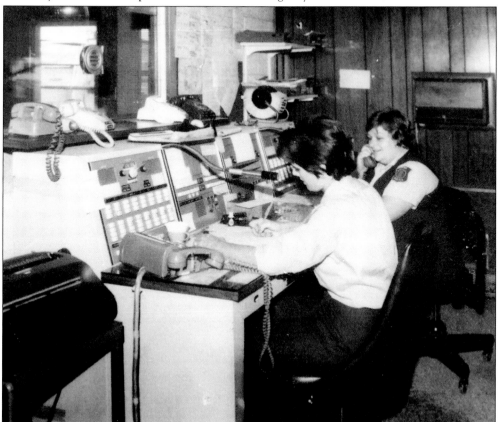

Local dispatchers worked in crowded conditions before their move to modern quarters in 1977.

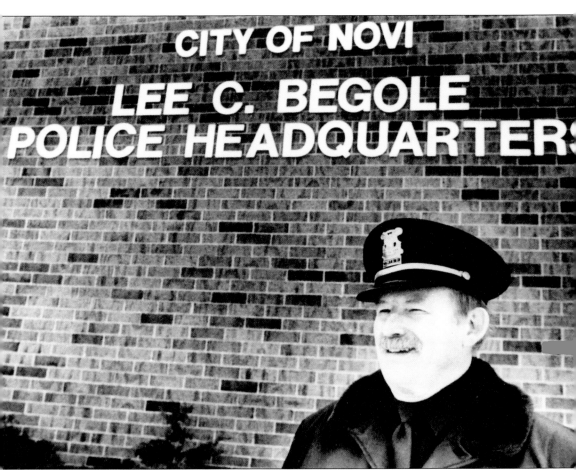

Lee BeGole was the first police chief of Novi, serving through village, township, and city incorporations. In his honor, the Novi Police Department Headquarters was named Lee BeGole Police Headquarters in 1991, shortly after his retirement.

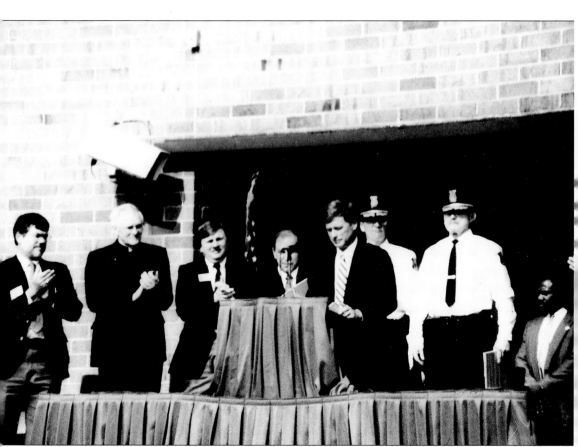

United States Vice President Dan Quayle was the keynote speaker at the ninth annual Novi Police Memorial Day on May 16, 1989. Police Memorial Day was created by President John F. Kennedy when he signed into a law a joint resolution on Congress establishing the first National Police Officer Memorial Day on May 14, 1962. The first National Police Week was held May 13–19, 1962. Since its initiation in 1980, the Police Memorial Day sponsored by the Novi Police Department has become one of the largest in Michigan.

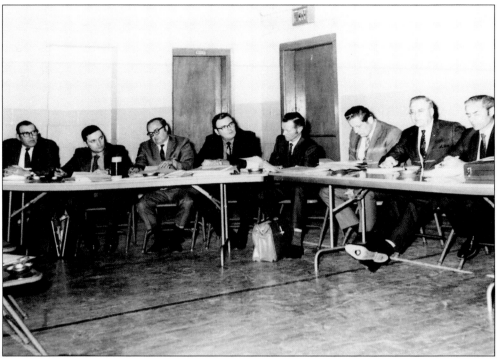

The first Novi City Council met in 1969. Mayor Joseph Crupi is pictured at the far right.

The earliest settlers who came to Novi usually had to settle for the services of an itinerant preacher who would stop every so often in the area to lead the scattered parishioners in prayer. However, a Presbyterian church was started in nearby Farmington as early as 1825. Directly across the street from the Novi Police Department is Faith Community Presbyterian Church, one of over a dozen churches in the city of Novi.

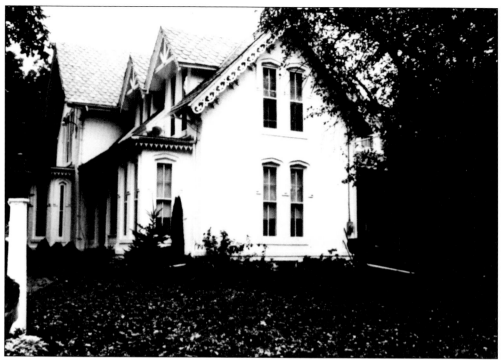

The home of Richmond Simmons and his family was the focal point of a farm that covered over 100 acres. More than 20 acres were devoted to fruit orchards.

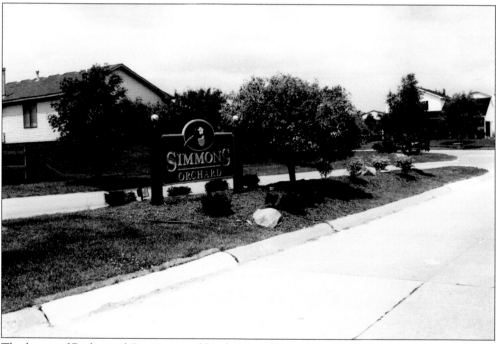

The home of Richmond Simmons and his family still stands today along Ten Mile west of Taft Road. While it was once the focal point of a farm and orchard that covered more than 100 acres, today it is surrounded by the Simmons Orchard Subdivision.

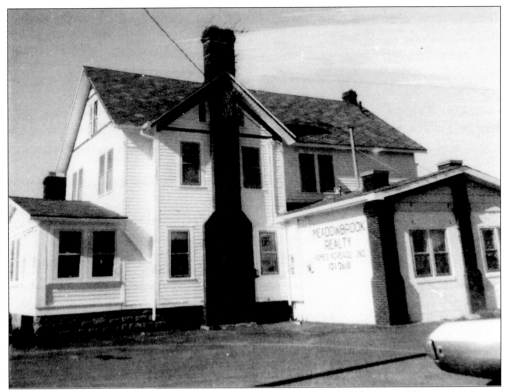

What began as Meadowbrook Realty was turned into an ice cream shop in 1979.

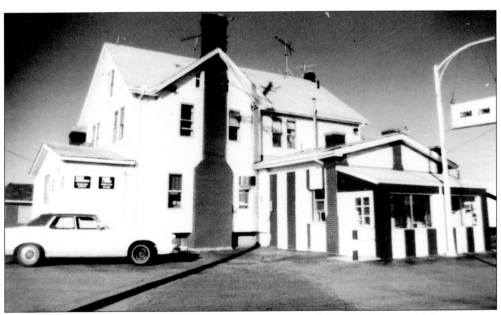

The "Cone Zone" is now known as "Twist & Shake," but still serves tasty treats. The ice cream shop is located in a 1940s-era lakeside cottage, previously used as a real estate office.

Four

Eleven Mile Road
Novi's School Center

Until just recently, Eleven Mile Road was a quiet dirt road. The paving of Eleven Mile was a controversial topic, but with new subdivisions appearing, it seems as though progress has won out. In the midst of the building boom, however, there are still pleasant wooded pockets of beauty seen throughout the city.

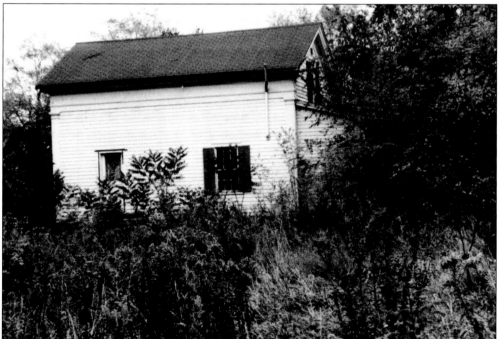

Sally Thornton was a widow with five children when she made the arduous journey to Novi from Caledonia, New York. The house the family built around 1839 has been moved a number of times. This photograph was taken after its move onto property located along Nine Mile Road, where it stood, awaiting its fate.

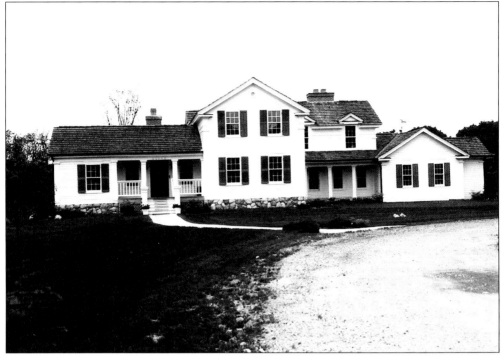

In 1990, Novi Historical Society President Kathy Mutch formed the "Friends of the Sally Thornton House" in an attempt to save the abandoned home. It was rescued by Northville resident Bill Garfield, who had the house moved to its current and permanent site off Eleven Mile east of Taft Road two years later. It has been renovated and is the focal point of yet another new subdivision in Novi.

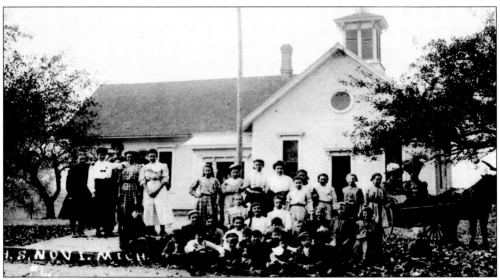

Schools in Novi began small, but like the population, grew with the demand. In 1864, a one-room frame schoolhouse was built, with a second room added a year later to handle the overflow. (Courtesy Northville Historical Society.)

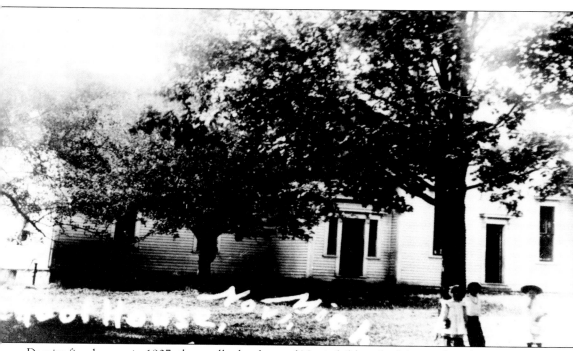

Despite fire damage in 1907, the small school served Novi children for 84 years, later becoming the Novi Convalescent Center. (Courtesy Northville Historical Society.)

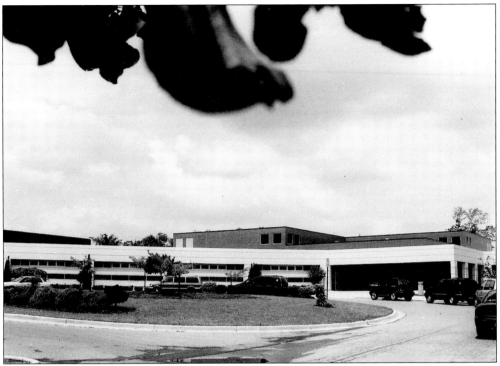

Located just south of Eleven Mile Road on Taft Road are the Novi School offices. By the 1960s, Novi had one of the fastest-growing school systems in the area. Today the administration complex is known as the Instructional Technology Center.

School is not just for fall and winter anymore. Classes in all topics are offered at all times of the year, such as Novi Soccer Camp, shown here in the summer at the school center complex.

Five

GRAND RIVER AVENUE
PUTTING NOVI ON THE MAP

The Grand River Road, which has connected Novi with Detroit since the early 1800s, began as an ancient Indian trail. Many of the early settlers coming to Novi traveled along this narrow, rugged path. In 1832, promoters were able to obtain funds for a "military highway" which would go from Detroit to the city of Grand Rapids, mouth of the Grand River, from which the road was to get its name.

By the 1850s, the rough, muddy trail was planked and it became known as the Detroit-Howell Plank Road. Stagecoaches made regular runs from Lansing to Detroit along this road, averaging about 12 hours one way.

Up through the 1950s, the Grand River highway was the main link between Novi and cities to the east and west. Many businesses grew up along this road, from its early days as Novi Corners in the 1830s.

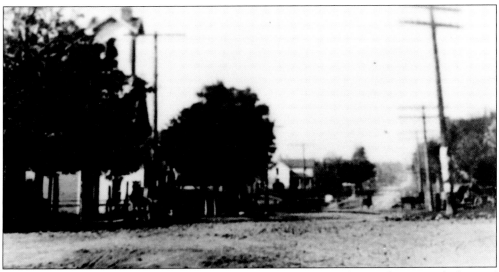

Novi's former "Main Street" is today known as Grand River. No longer dirt covered, the road has been built up considerably.

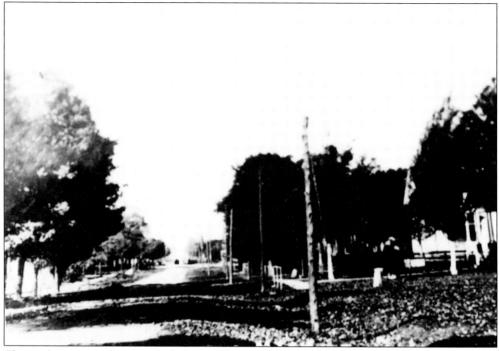

This early section of town was first settled around 1830 by pioneers who helped develop the area as the first business section in Novi Township.

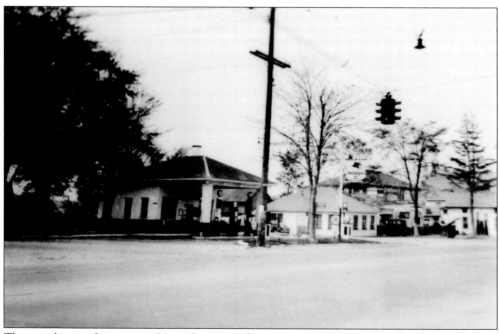

The area known for years as "Novi Corners," the intersection of Novi Road and Grand River, became the town's central business district as early as 1830. This view, taken in the early 1930s, looks west along Grand River. The Methodist Church is visible on the far right. (Courtesy Burton Historical Collection of the Detroit Public Library.)

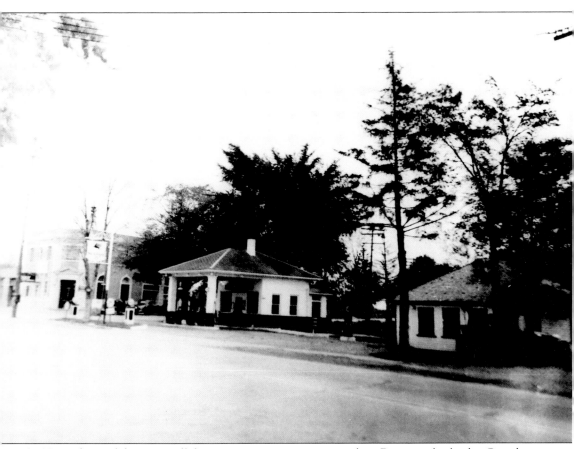

As Novi changed from a small farming community to a sprawling Detroit suburb, the Grand River/Novi Road intersection—still known by oldtimers as "Novi Corners"—remained the unofficial center of town. (Courtesy Burton Historical Collection of the Detroit Public Library.)

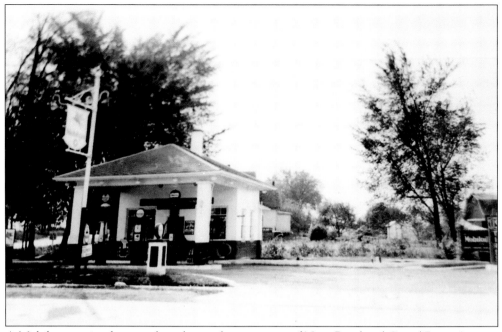

A Mobil gas station has stood on the southwest corner of Novi Road and Grand River Avenue for over 60 years.

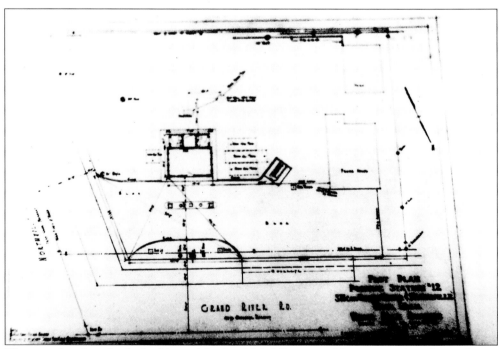

These are the plans for the building of the first Mobil Station in Novi, situated on the southwest corner of what is now called Novi Road and Grand River in 1935. (Courtesy Burton Historical Collection of the Detroit Public Library.)

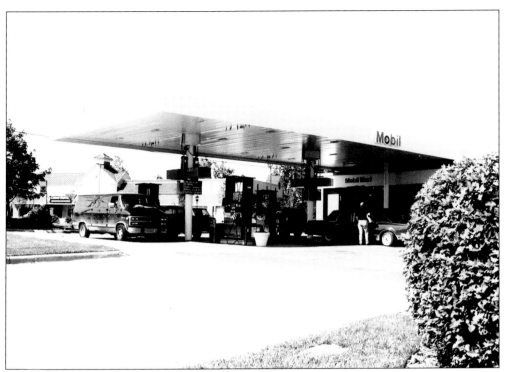

Today's Mobil gas station features flower gardens and several more pumps.

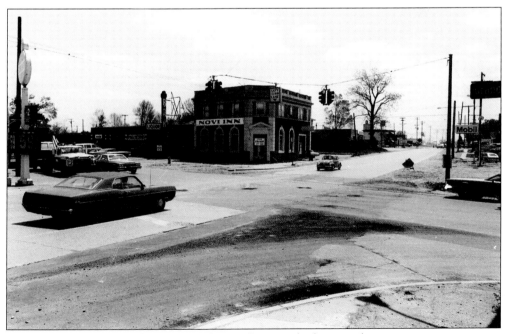

This photograph shows all four "Novi Corners" as seen looking southeast.

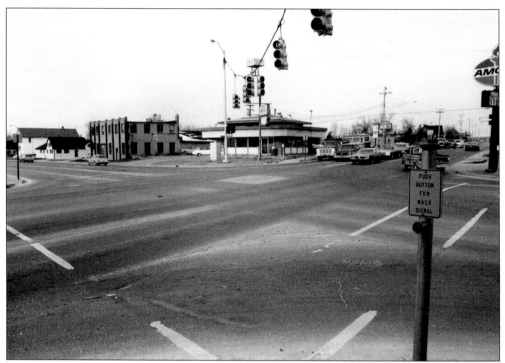

What became the oldest hotel in Michigan had a long life, but it came to a deliberate end. In 1927, the owner opted for progress by tearing down the historic building to build a gas station.

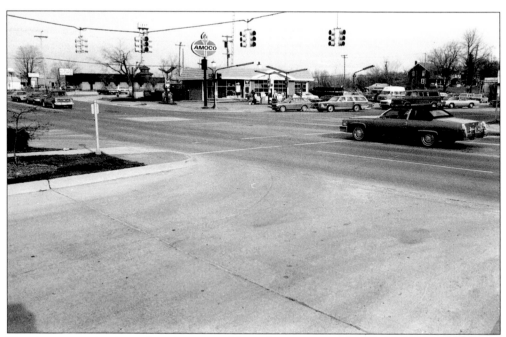

The Amoco station has a long history in Novi. A gas station stood on the northeast corner of Grand River and Novi Roads since the 1920s, in response to the influx of automobiles in the area.

–Elect–
LEO HARRAWOOD
FOR
NOVI TOWNSHIP
SUPERVISOR
– IN –
PRIMARY ELECTION FEB. 16, 1953
REPUBLICAN

Local realtor Leo Harrawood owned the gas station from 1949 to 1992, operating it himself until 1963. The station was full service and more, offering 24-hour service, a restaurant, bus station, 24-hour used car lot, and even two radio-dispatched, oxygen-equipped ambulances. Leo's Gas Station began as a Standard Oil station in 1955, switching over to Amoco in later years. (Courtesy Northville Historical Society.)

The site of the old Novi Hotel and later the Standard/Amoco gas station, is today a scenic expanse of greenery in the center of the city.

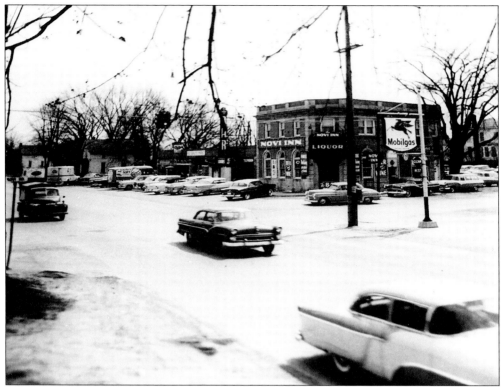

The building which stands at the southeast corner of Novi Road and Grand River, pictured in this photograph as the Novi Inn, was originally erected as a bank.

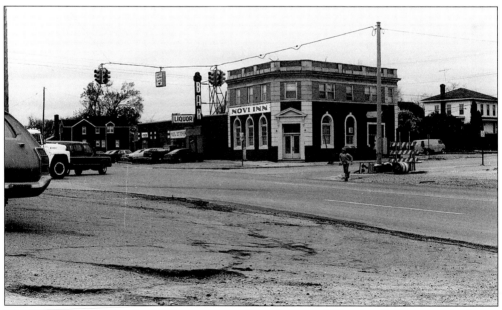

The Novi Inn, built in the 1930s, was erected on the site of Blanchard's Tavern, which was built one hundred years earlier.

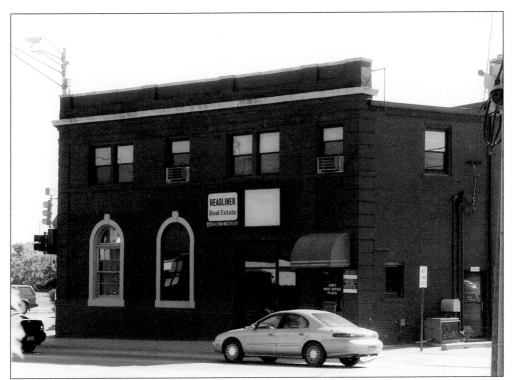

Unfortunately, the building was completed just in time for the bank failures of the 1930s, and has never been used as a bank.

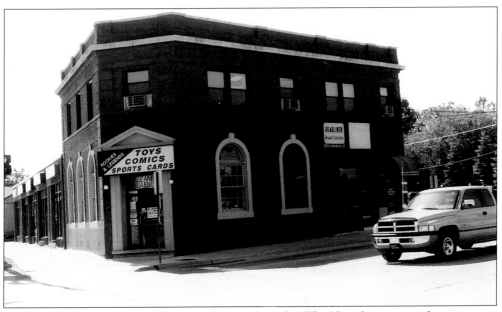

The old Novi Inn still stands, but is no longer a hostelry. The Novi Inn remained in operation through the 1980s. Since then, the building has been used for a variety of businesses. Nationwide hotel chains have taken up where the Novi Inn left off, and today there are at least half a dozen hotels and motels in the city.

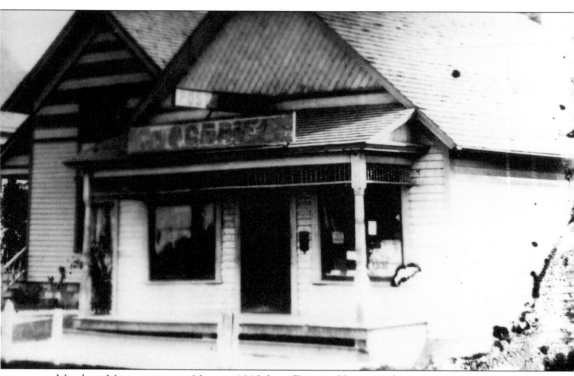

Matthew Moeren came to Novi in 1912 from Detroit. His general store carried everything from dry goods to horse collars, and Moeren reportedly acted as owner, general manager, clerk, and handyman. Moeren's Grocery Store was located on the northwest corner of Grand River and Novi Road. (Courtesy Northville Historical Society.)

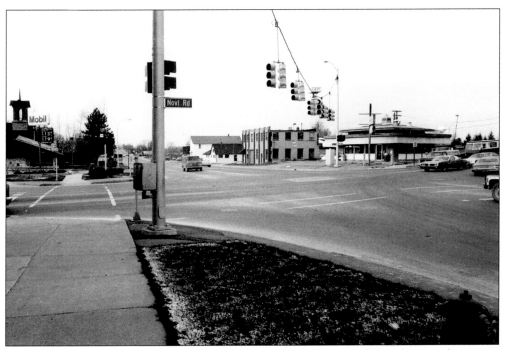

Dave's Hamburgers, pictured in the upper right of this photo, was built on the site of Moeren's General Store in the 1960s. The Methodist Church, with its steeple, is visible across the street.

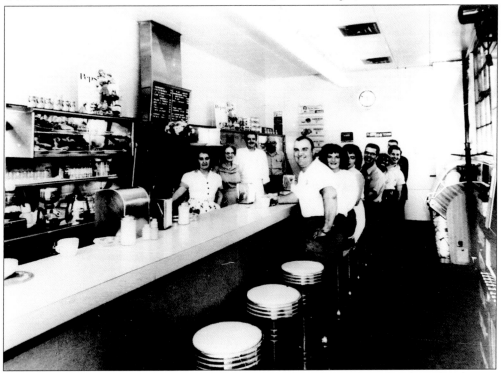

Dave's became a meeting place for residents all over town. Known far and wide as the place to go in Novi, Dave's Hamburgers sent the smell of good food drifting throughout the Novi air.

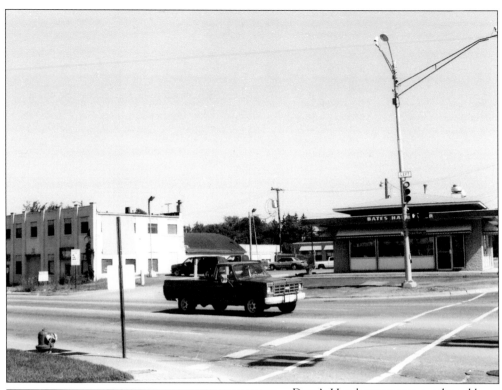

Dave's Hamburgers was purchased by Bates' Hamburgers around 1985–86. The scent of burgers still permeates the air, but the fate of the old hamburger stand hangs in the balance, and the landmark may not last for long.

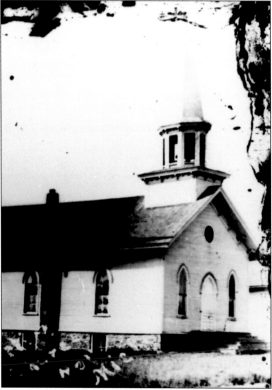

Novi's First Baptist Church was constructed in 1846. It burned in a fire caused by an electrical storm in 1913 that also destroyed the next-door township hall. (Courtesy Northville Historical Society.)

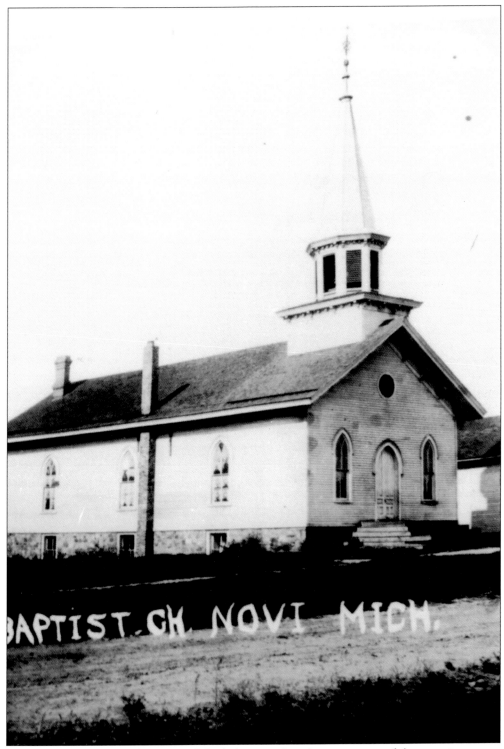

The steeple of the church was struck by lightning, thus destroying two of the most important buildings in the town at the time. (Courtesy Northville Historical Society.)

The Novi Methodist Church on Grand River Avenue was built in 1875. It was spared from the fire that destroyed the nearby Baptist church and township hall in 1913. (Courtesy Northville Historical Society.)

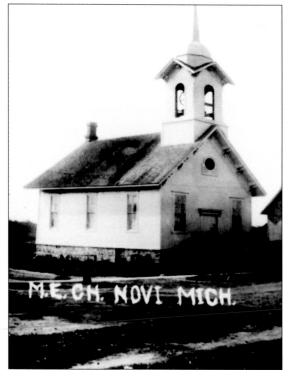

The steeple of the Methodist Church, pictured in this turn-of-the-century photo, was removed in the 1980s. (Courtesy Northville Historical Society.)

In this view looking west on Grand River in the early part of the 20th century, the peaceful rural flavor of Novi is evident.

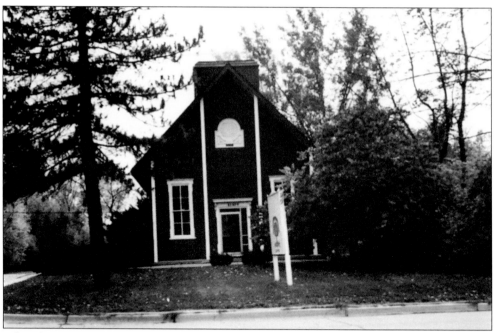

After closing as the Methodist Church, the building served for many years as a childcare center before being abandoned in the 1990s.

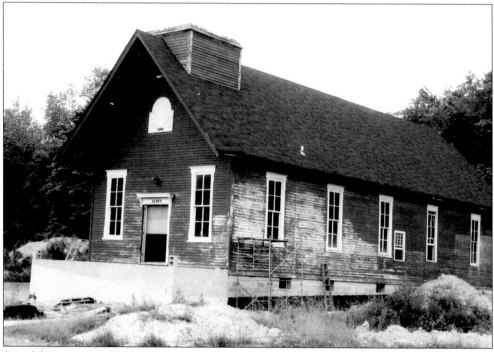

Saved from extinction, the Novi Methodist Church was moved from its Grand River location to a site along Beck Road in 1997. It will soon be used by Novi's Oakland Baptist Church.

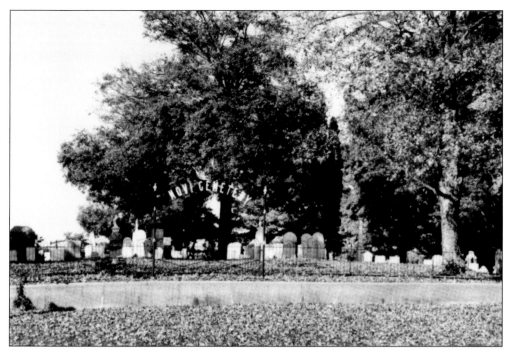

The Novi Cemetery sits atop a hill along Novi Road near Grand River. Many of the area's earliest settlers are buried here.

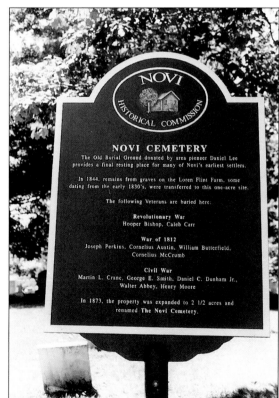

Two Revolutionary War veterans lived in Novi during the early years of the community. Both Caleb Carr, a Methodist preacher, and Hooper Bishop are buried in Novi Cemetery. Bishop was the oldest resident of Novi when he died in 1861 at the age of 99.

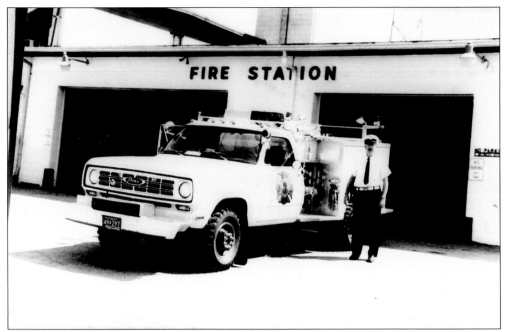

Novi's Fire Department was physically part of the Novi Police Department in the 1950s. Here, Police Chief BeGole wears his "Fire Chief" hat.

The Novi Fire Department has come a long way from the days of its first fire truck in 1929.

In 1928, a brick structure was created on Novi Road north of Grand River. From this four-classroom building, grades one through ten were maintained for several years.

In 1951, a five-classroom addition was completed. In the fall of 1955, voters approved the construction of a ten-room classroom addition to the school.

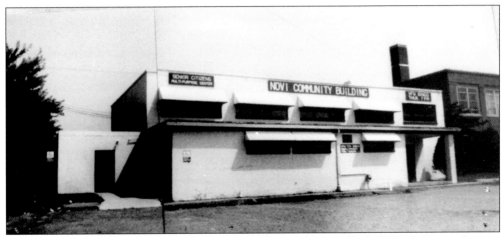

Novi Community Building was adjacent to the original Novi High School. It acted as an auditorium for both the school and the community. Both buildings were demolished in the mid-1980s to make way for the Town Center Shopping Center.

Many city offices were scattered in buildings located along and near Grand River Avenue. The Parks and Recreation Offices were located in an annex of the Community Building.

A number of former homes were used to house city offices before their move to a central location in the 1970s. The Engineering and Water Department was located in this building.

The Maintenance building was situated in a converted house.

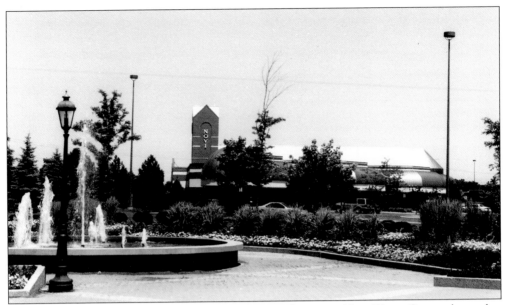

In 1987, a multi-million dollar shopping development known as Novi Town Center, located at Novi Road and Grand River, brought the focus back to "Novi Corners." When Town Center broke ground in 1986, it was considered to be the beginning of downtown Novi, according to then Mayor Patricia Karevich.

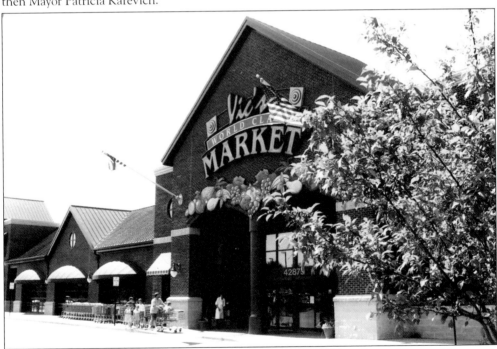

The building boom continues with Novi's latest development, "Main Street." Located just south of Novi Town Center, the area hopes to include homes, shopping, and entertainment places in an attempt to re-create a small-town "Main Street" atmosphere. Vic's World Class Market was the first tenant on Novi's new Main Street when it opened in 1995. The *Detroit News* claimed that "Novi's Main Street tries to capture [the] ambiance of old."

Crawford's Lumber Company was owned and operated by Jack Crawford. Located on Grand River, next to Leo Harrawood's gas station, it is seen here in June 1948.

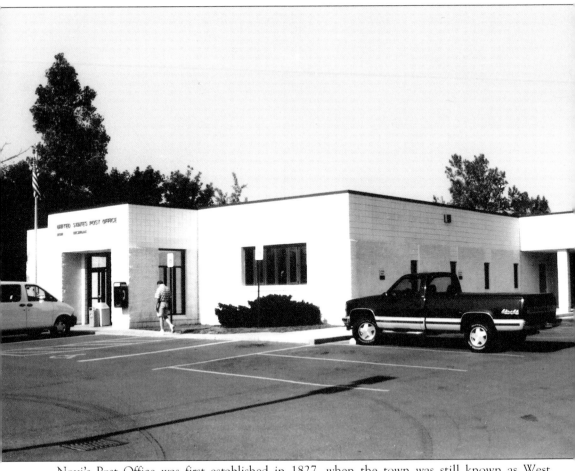

Novi's Post Office was first established in 1827, when the town was still known as West Farmington. The establishment of the post office in the growing community was the beginning of the town's breaking away from Farmington. The current U.S. Post Office, located on Novi Road south of Grand River, offers a wide array of services, from selling stamps to note paper and neckties.

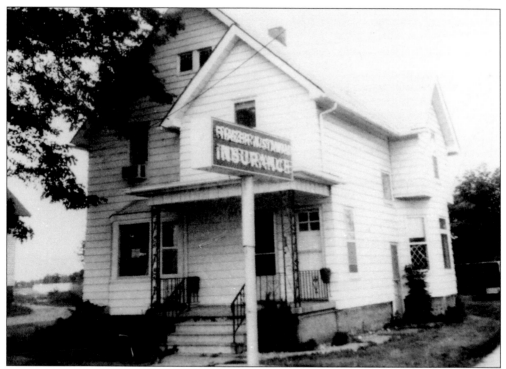

Frazier Staman was one of the city's early supporters. A former Novi Township supervisor, he was also chairman of the Oakland County Road Commission and received the Liberty Bell Award, presented by the Oakland County Bar Association. His insurance company office, located on Novi Road near Grand River, was a landmark well into the late 1990s.

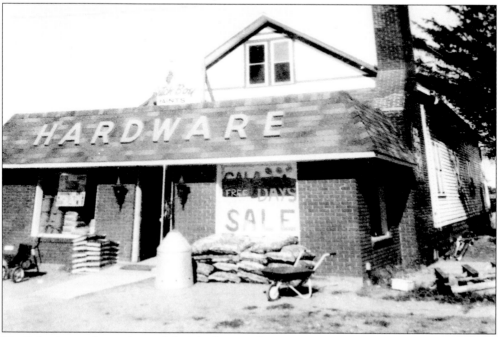

Novi's businesses have changed their looks over the years.

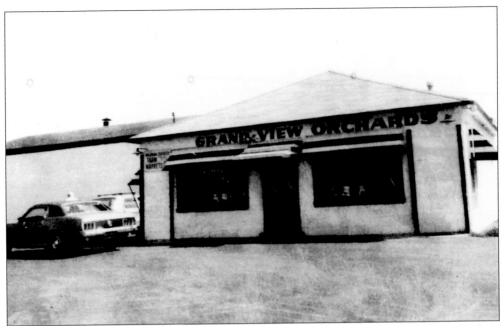

Grand View Orchards was located on Grand River Avenue during the 1970s, the site of today's Tab Products Company.

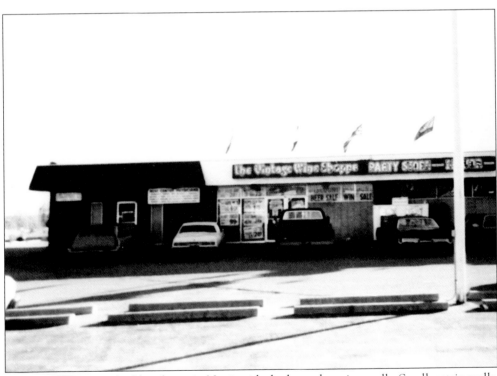

The 1970s saw major building begin in Novi, with the huge shopping malls. Smaller strip malls, like Novi Plaza seen here in 1979, today seem quaint by comparison.

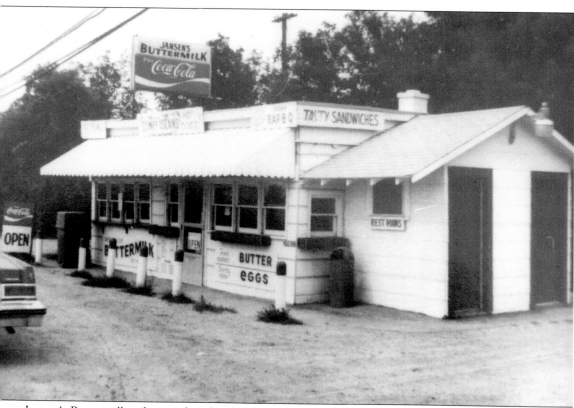

Jansen's Buttermilk, advertised as the "best you ever tasted," was reportedly sought after from miles around. The restaurant and dairy was located close to the eastern limits of Novi, on what is now the property of a Mercedes-Benz dealership. Today's dairy lovers look to Guernsey Farms Dairy on Novi Road.

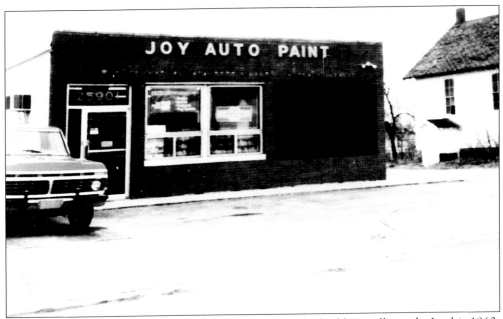

Joy Auto Paint Company is no longer in business, but the building still stands. In this 1960s photograph, the old Novi Town Hall is visible next door on the right.

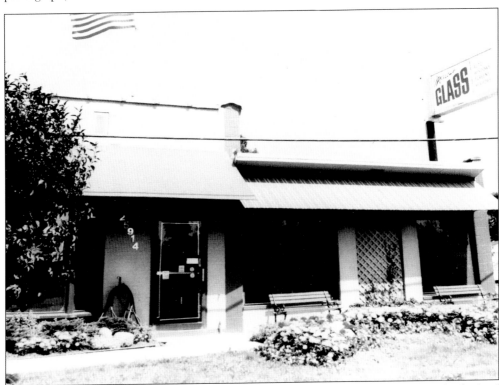

The Novi Beautification Committee has inspired current businesses to improve the look of their buildings, as shown in this photograph of the Marcus Glass Company, located on Novi Road, south of Grand River. The business is now known as Harmon Glass.

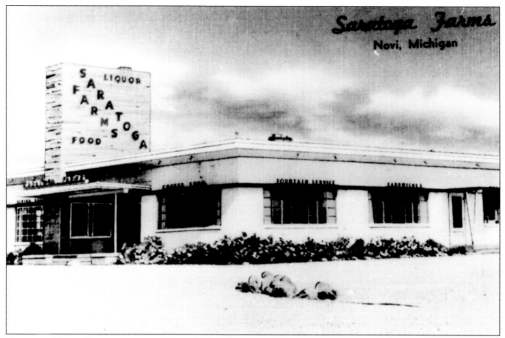

Saratoga Farms Restaurant in Novi, located along Grand River Avenue, provided a convenient stop for Novi residents and travelers along the highway.

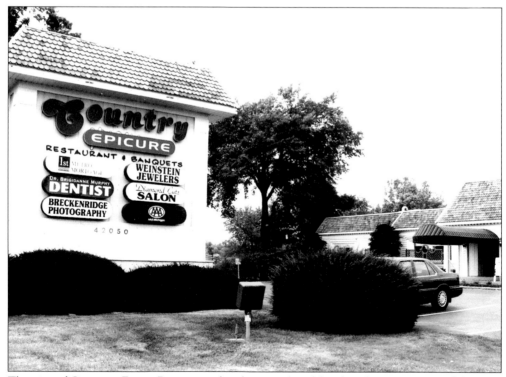

The site of Saratoga Farms Restaurant has been replaced by the elegant cuisine of Country Epicure, along with a small strip-mall.

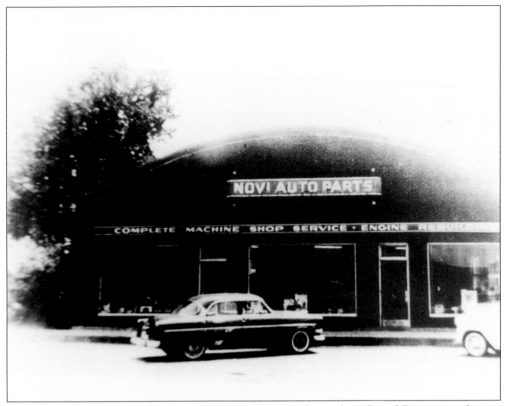

Novi Auto Parts has served Novi since 1925. Originally located on Grand River next door to Moeren's Grocery/Dave's/Bates' Hamburgers, it moved to its current location east of Novi Road in the 1970s.

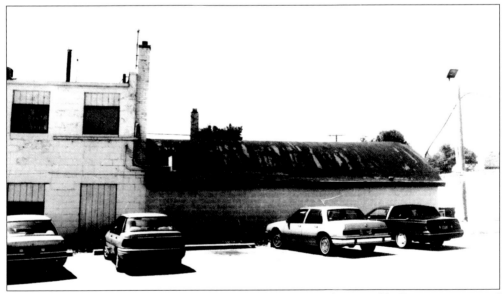

The building that once housed Novi Auto Parts still stands, and is owned by Frazier Staman and Son. The lower level most recently served as an art studio and cappuccino bar.

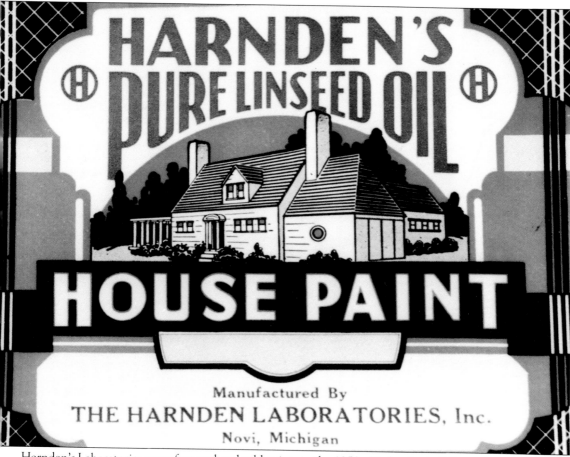

Harnden's Laboratories manufactured and sold paints in the 1950s. Today the building is owned by Stricker Paint Products, which has been at the same location on Novi Road since 1965. (Courtesy Northville Historical Society.)

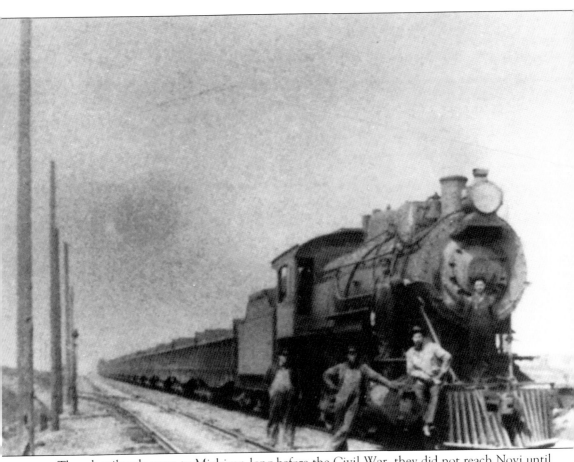

Though railroads came to Michigan long before the Civil War, they did not reach Novi until the 1870s. Pictured above is the first locomotive in Novi.

The train first came to Novi in 1876, linking it with Detroit and other parts of the state.

Building the railroad through Novi was an historic event, as it connected Novi with the rest of the world—or at least from Plymouth to Holly.

The railroad proved to be an expedient alternative to the earlier slow-moving stagecoaches.

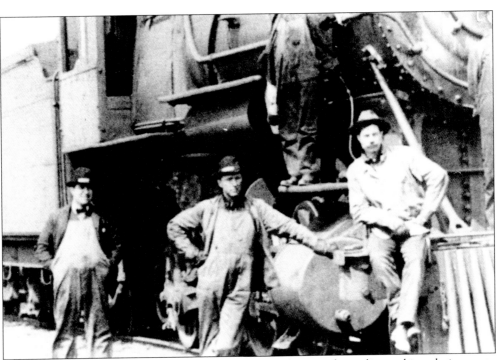

Trains provided efficient transportation for Novi residents and supplies making their way to other parts of Michigan.

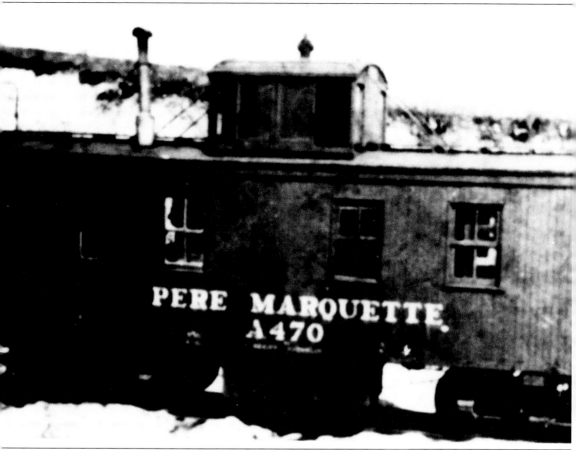

The Pere Marquette caboose became a familiar sight, trailing behind the rest of the train as it sailed through Novi.

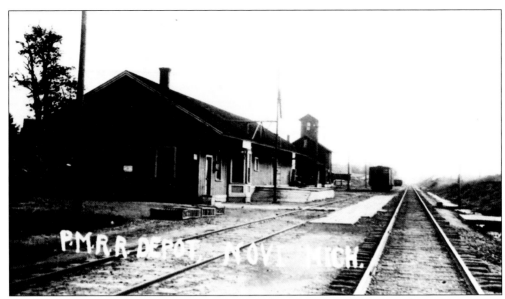

The Pere Marquette Railroad Depot, constructed near Novi Corners in the 1870s, was an important addition to the town. (Courtesy Northville Historical Society.)

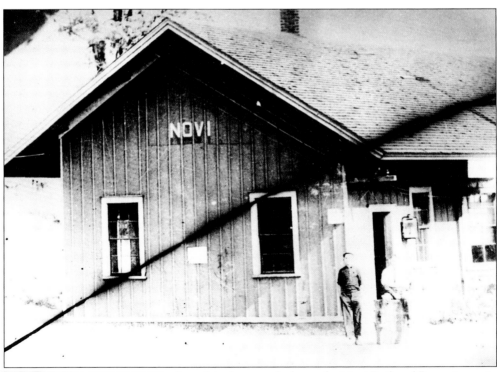

Reproduced from a broken glass plate, this photograph shows the Novi Railroad Depot in use in the 1890s. (Courtesy Northville Historical Society.)

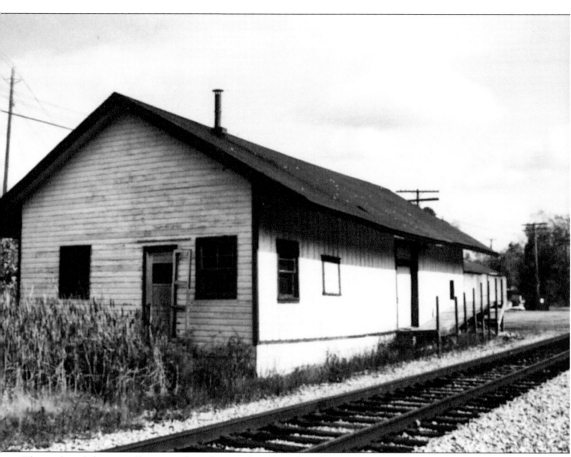

The railroad depot still exists, though it is abandoned and overgrown.

The railroad trestle, built in the early 1920s to serve the increasing use of automobiles, still stands.

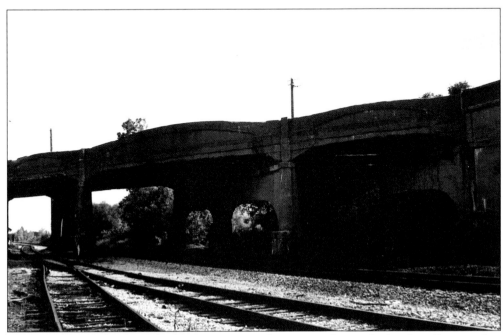

The unstable condition of the historic overpass has put its fate in limbo. It still exists, but perhaps not for long.

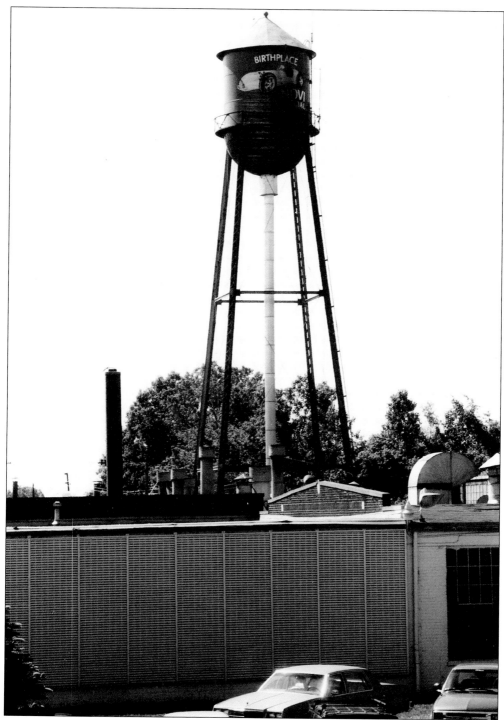

An innovative racing car was created in 1941 by inventor Ed Winfield. Funded by the owner of the Novi Equipment Company, Lewis Welch, the car became known as "the Novi Special" and became Novi's symbol of success. Its picture proudly reigns over Novi on this old water tower along Novi Road south of Grand River.

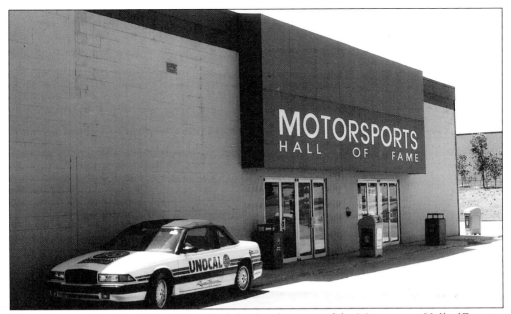

The existence of the Novi Special inspired the development of the Motorsports Hall of Fame in Novi, located just north of Grand River near Novi Road.

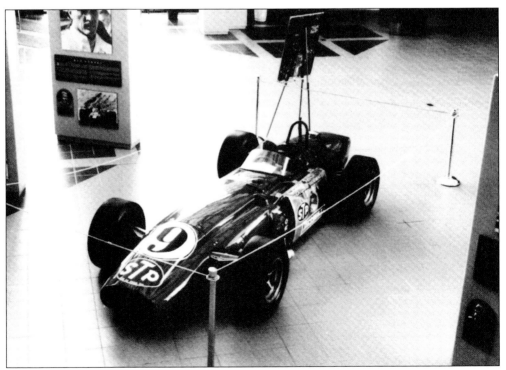

Before being housed in the Motorsports Hall of Fame, the Novi Special shone regally in its temporary place of honor in the newly opened Civic Center lobby in 1988.

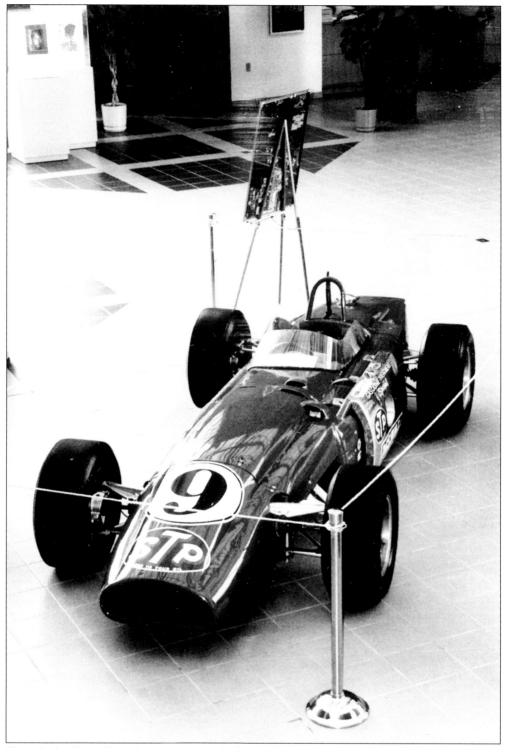

Though the Novi Special never won any Indianapolis 500 races, it set numerous records during its 20-year life span, including time for the fastest field and fastest qualification.

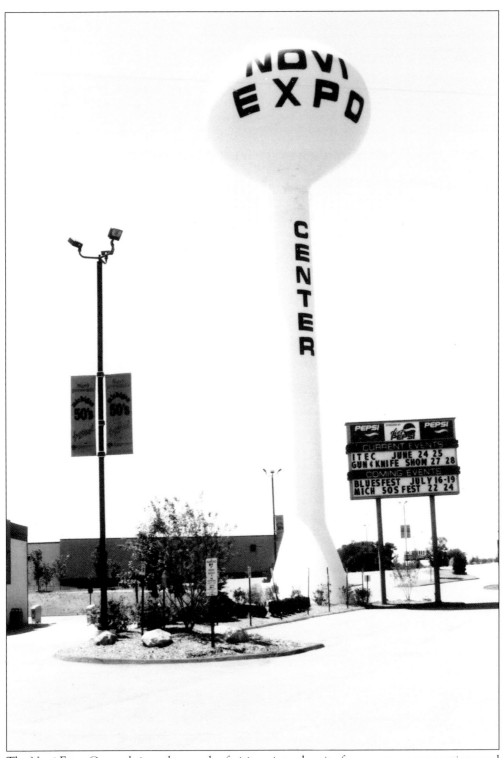

The Novi Expo Center brings thousands of visitors into the city for numerous conventions and shows every year. It celebrated its grand opening in 1992.

Six

TWELVE MILE ROAD
AN AREA OF CONTRASTS

By the 1970s, Novi had become a boom town. With the building of Twelve Oaks Shopping Mall in 1977, many others soon followed; Novi is today a mecca for shoppers. Though the area along Novi Road between Grand River and Twelve Mile is possibly the busiest section of Novi, driving along Twelve Mile Road brings one into direct contact with working farms surviving next to suburban development.

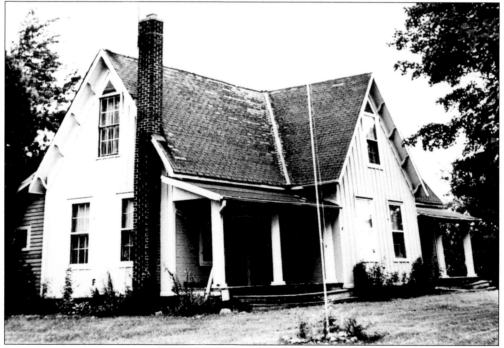

Loren Flint and his family came to Novi in the late 1820s. They settled on land along what is today Twelve Mile Road and built this house around 1830. (Everett.)

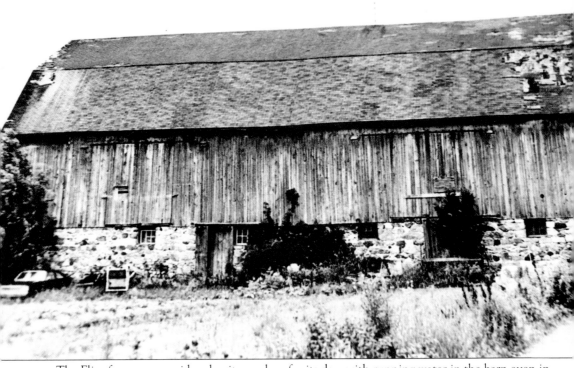

The Flint farm was considered quite modern for its day, with running water in the barn even in its earliest days. Both the house and barn still exist today. (Everett.)

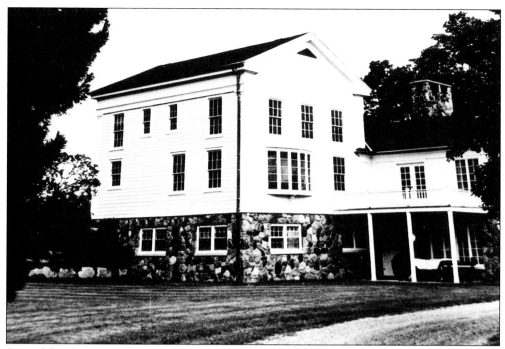

Samuel Bassett was another early Novi resident. His home, built around 1840, was known as Tollgate Farm. (Everett.)

Located at the corner of Twelve Mile and Meadowbrook Road, Tollgate Farm is currently a training center run by Michigan State University. The barns are just part of the working farm run on the grounds. (Everett.)

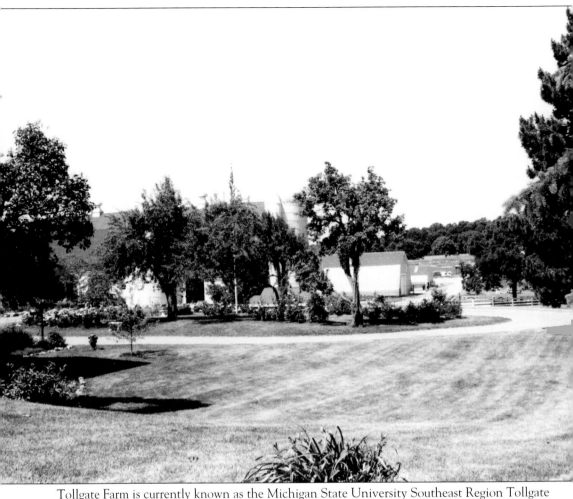

Tollgate Farm is currently known as the Michigan State University Southeast Region Tollgate Education Center.

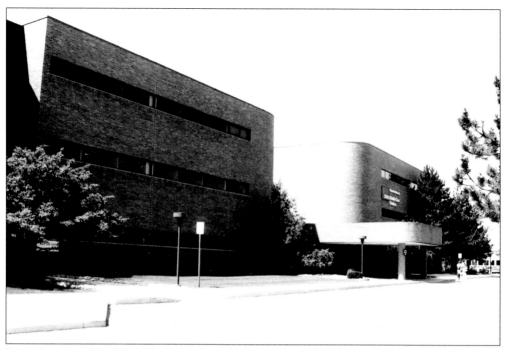

Directly across Twelve Mile Road from Tollgate Farm stands the Detroit Medical Center Health Care Offices. The Novi branch of the DMC was formerly known as the Woodland Medical Center.

The Detroit Medical Center was formed in 1973 with the cooperation of Wayne State University Medical School, Harper, Grace, Hutzel, and Children's Hospitals, and the Rehabilitation Institute. This is the Novi Rehab Center, located next door to DMC Novi.

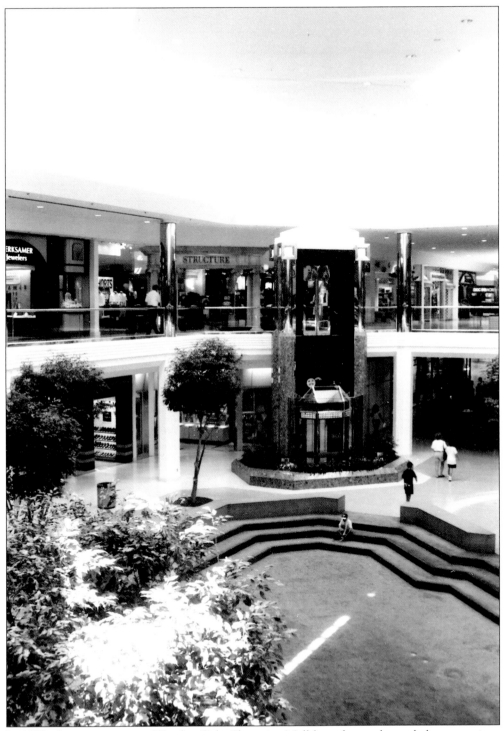

In 1977, the construction of Twelve Oaks Shopping Mall brought much-needed revenue into the area, and began a building boom that continues to this day.

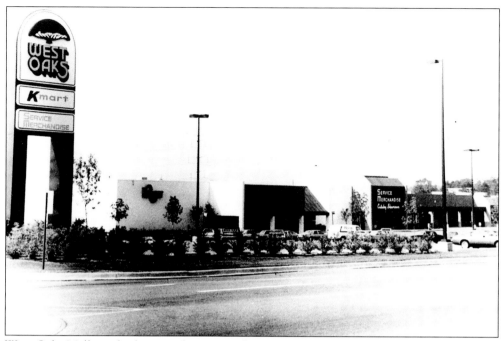

West Oaks Mall was built west of Novi Road, across from the highly successful Twelve Oaks Mall. West Oaks Two followed shortly after.

This view of Novi Road looking north was taken before West Oaks Shopping Mall was built.

Oakland Hills Memorial Gardens and Mausoleum, a non-denominational cemetery, is the largest cemetery in the city. It was opened in the early 1930s at the corner of Novi Road and Twelve Mile.

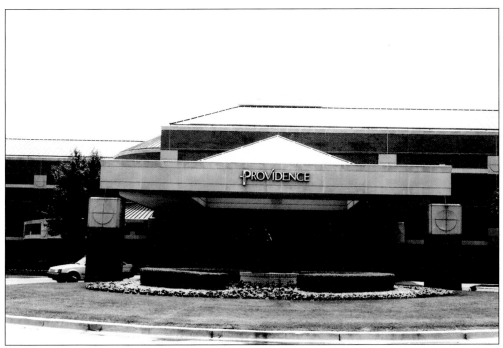

There are many health care facilities in Novi. Among the largest is Providence Park Outpatient Medical Facility, built in 1992 and located at Beck Road and Twelve Mile.

Built on the site of the former Bob-o-Link Golf Course, Providence Park Medical Facility was required by the city to provide a golf course as part of their complex. Westbrooke Golf Course weaves around the hospital to complete its nine-hole course.

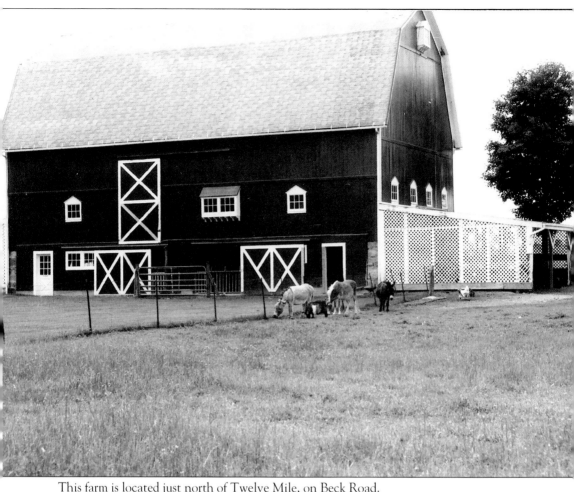

This farm is located just north of Twelve Mile, on Beck Road.

Seven

THIRTEEN MILE ROAD
THIS JOINT WAS JUMPING

Walled Lake, three-quarters of which lies within the city of Novi, begins at Thirteen Mile Road. It has been the scene for recreational pursuits for centuries. A stopping place for Native Americans traveling along the ancient trail between Detroit and Flint, it became a favorite resort for later area residents.

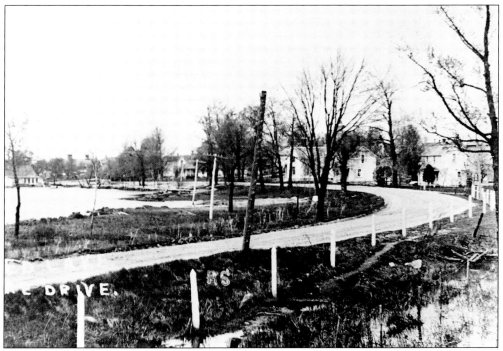

In 1910, Walled Lake Drive was a dirt road that crept peacefully past summer cottages and the placid waters of the lake.

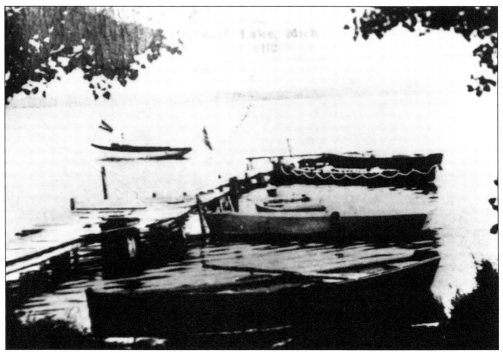

Walled Lake has not changed much over the years, as seen in these two photographs taken nearly a century apart.

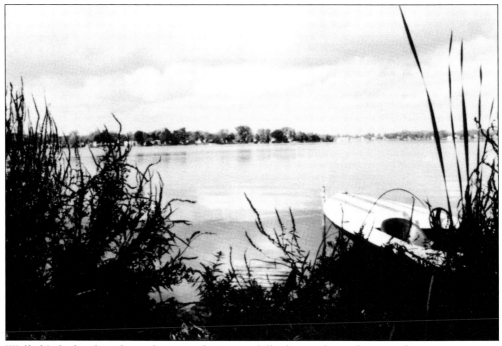

Walled Lake has long been the scene for many idyllic boat rides and sunny afternoons.

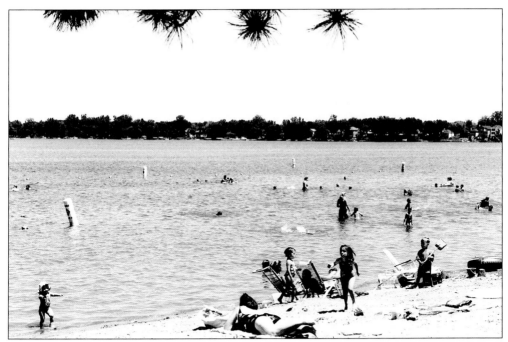

Lakeshore Park, Novi's only bathing beach, also contains 200 acres of wooded bike paths and hiking trails.

Excursions to Walled Lake by Detroiters was considered an adventure in the mid-19th century. It even substituted for a trip to Michigan's scenic north.

Improved roads and the accessibility of the automobile by the 1920s brought Walled Lake into easy reach of most Detroiters, and many flocked here to rent summer cottages.

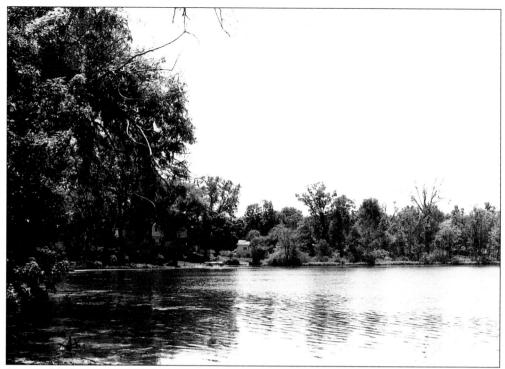

Shawood Lake is a small lake located just south of Walled Lake, with a tributary connecting the two.

Traffic in Novi was heavy in the 1950s, especially leading to the lake on summer weekends.

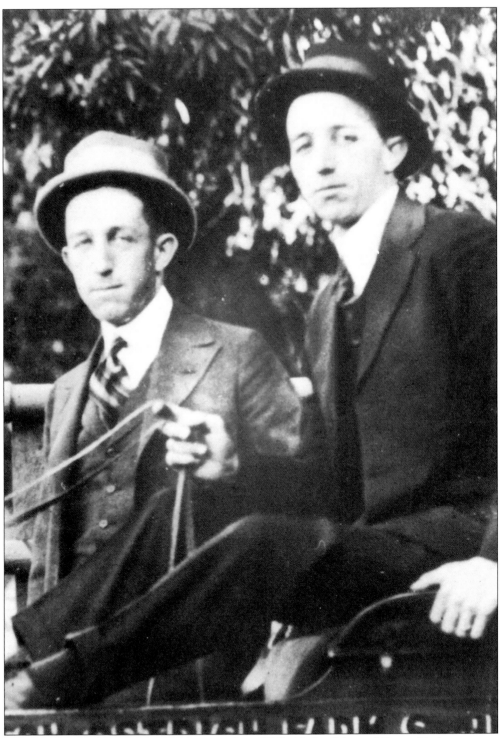

Shortly after World War I, two young men from Walled Lake, Jake and Ernest Taylor, were to take on an enterprise that would change the look of the area for decades.

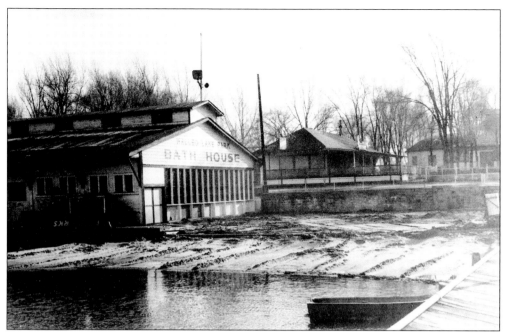

The Taylor brothers, with their father, Judd, opened the Walled Lake Bath House in 1919. The Bath House proved so successful that it inspired competition in the area.

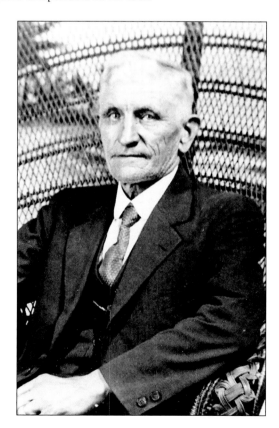

Next-door neighbor Herman Czenkusch was not to be outdone. Czenkusch built a subdivision, naming it Cenaqua Shores.

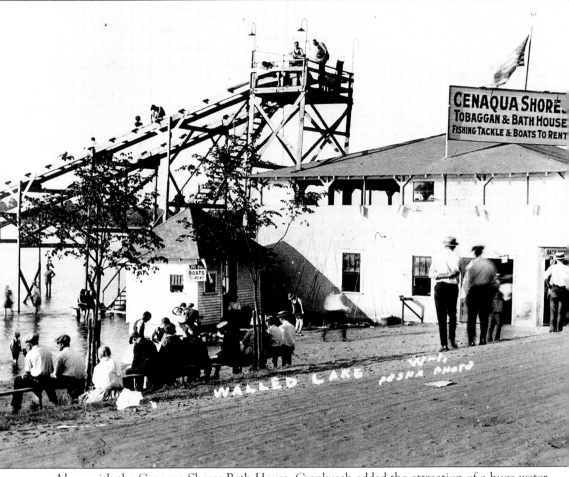

Along with the Cenaqua Shores Bath House, Czenkusch added the attraction of a huge water slide. The water slide proved immensely popular and drew great crowds to the lake.

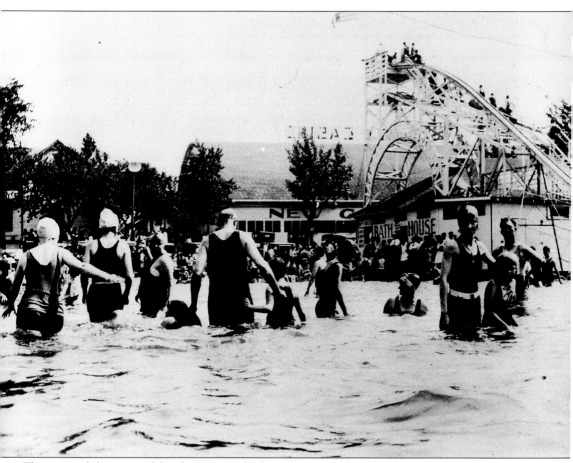

The water slides enjoyed by these 1920s bathers eventually became dangerous. After a fatal accident in the early 1930s, the slides were closed and soon dismantled.

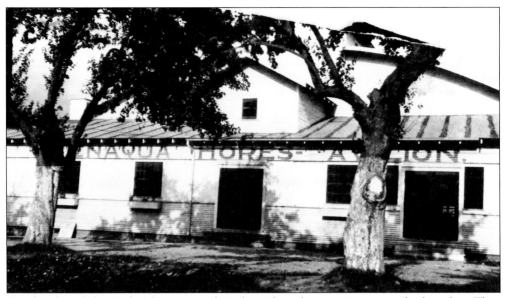

Czenkusch and the Taylors became avid rivals, with each one trying to outdo the other. They both added dance halls, and Czenkusch even included the newfangled motion pictures to his park.

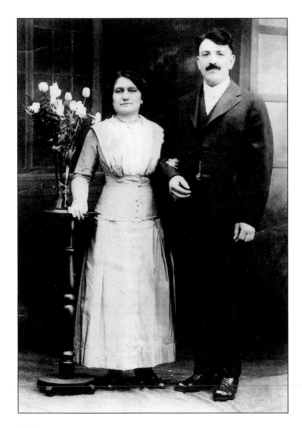

In 1923, the Taylors sold their Bath House and Dance Hall to Louis B. Tolettene. He is pictured here with his wife, Leona.

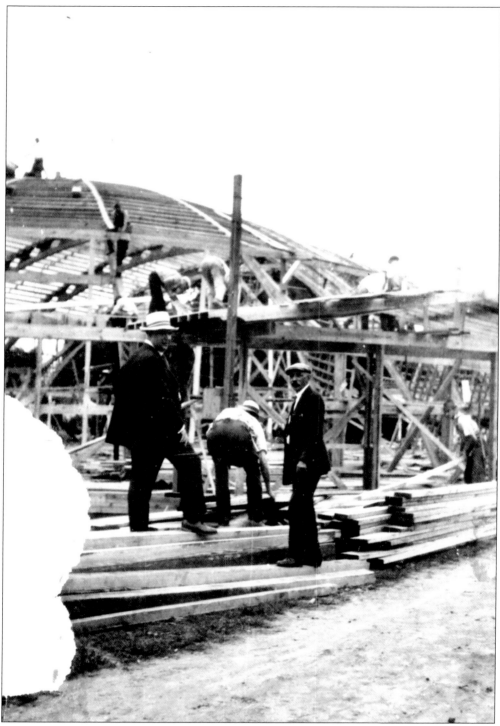

Tolettene, a Detroit grocer, purchased the Taylor's dance hall, remodeled it, and renamed it Casino Shores Pavilion.

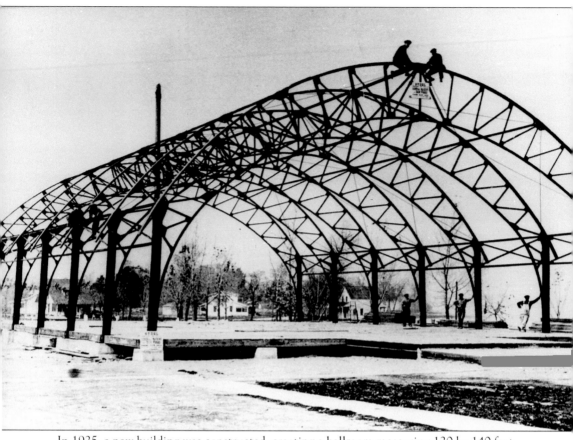

In 1925, a new building was constructed, creating a ballroom measuring 120 by 140 feet.

The new building was named the New Casino, and it opened in April 1925.

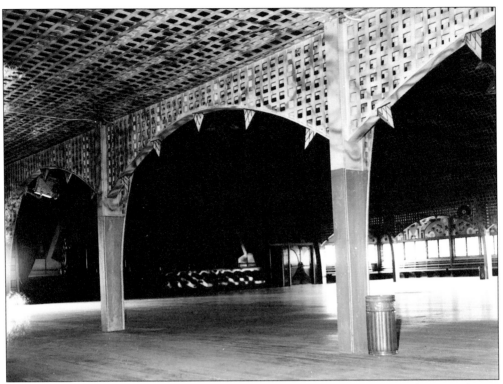

With a polished maple dance floor and intricate lattice work decorations, the New Casino Dance Hall was a welcome spot for dance lovers in the "Roaring Twenties."

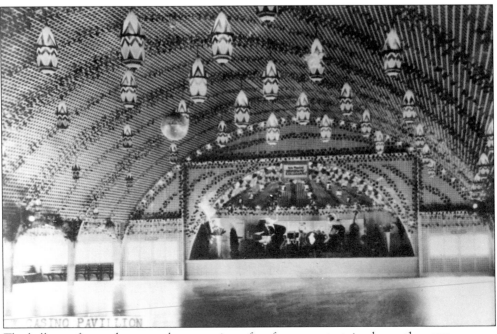

The ballroom featured a stage where a variety of performers entertained over the years.

Meanwhile, at Cenaqua Shores, Herman Czenkusch's health was failing, and he leased his casino to Novi resident Howard S. Staman.

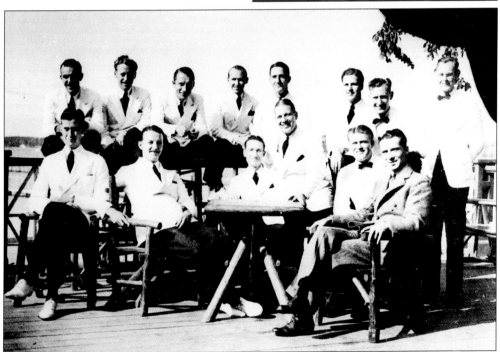

Staman was unable to make a go of the business, and in 1927, L.P. Tolettene leased the Cenaqua Shores Dance Hall. In order to draw bigger crowds, Tolettene hired the nationally known band, the Broadway Collegians, to headline the 1928 season.

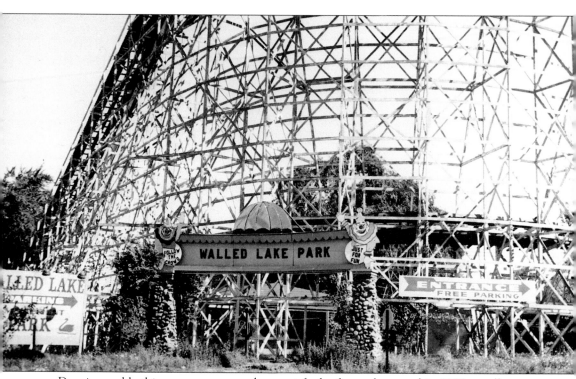

Dancing and bathing were not enough to satisfy the fun-seekers, and in 1929, a roller coaster was installed at Walled Lake by Fred W. Pearce.

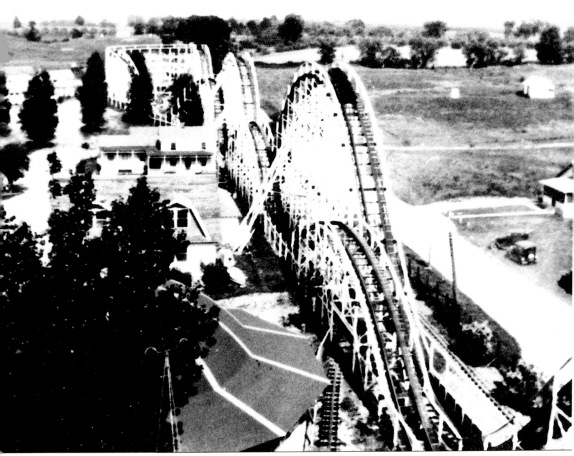

Pearce leased Czenkusch's original property in order to build his amusement park.

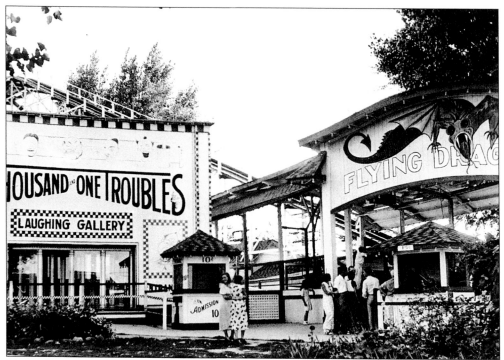

The "Flying Dragon" at Walled Lake was considered to be the best roller coaster Pearce ever built.

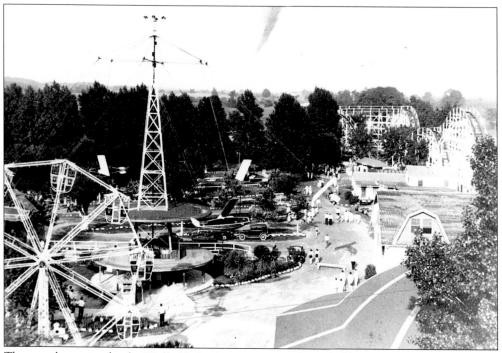

The grand opening for the Walled Lake Amusement Park was held on Memorial Day in 1929.

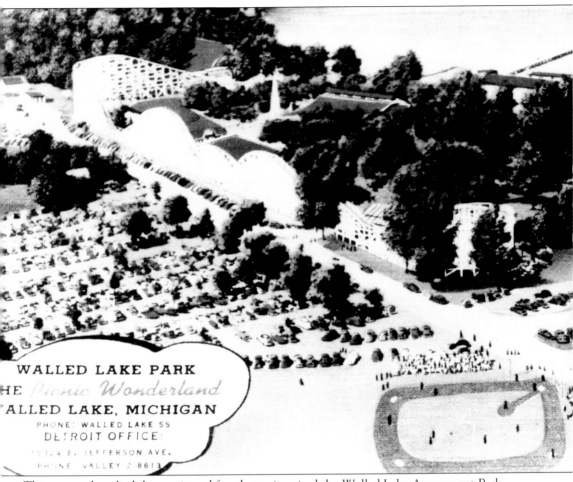

WALLED LAKE PARK
HE *Picnic Wonderland*
ALLED LAKE, MICHIGAN
PHONE: WALLED LAKE 55
DETROIT OFFICE:
15324 E. JEFFERSON AVE.
PHONE VALLEY 2 8613

This postcard evoked the magic and fun that epitomized the Walled Lake Amusement Park.

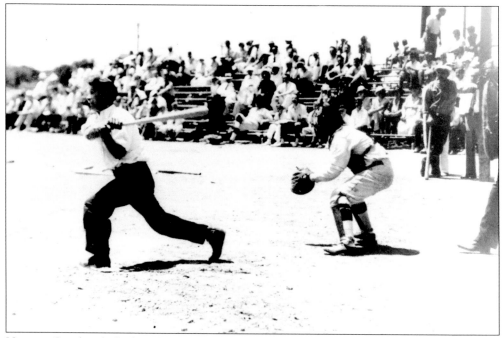

Herman Czenkusch died in August 1929, but his creation of an entertainment center around Walled Lake continued. Walled Lake became popular for company picnics through the 1930s and 1940s. This softball game was sponsored by the Detroit Association of the Deaf, who played versus "non-members." Free admission, free parking, and free ice cream were offered to all who participated.

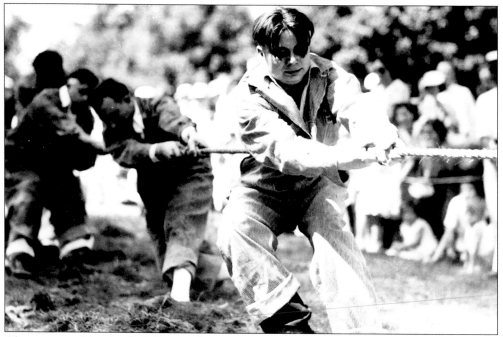

Also sponsored by the D.A.D. was this "Tug-o-War" between married and single men. The outcome of the event remains unknown.

Fred Pearce, builder of "The Flying Dragon" roller coaster, is seen here with his daughter Ethel at a staff picnic at the park in 1940.

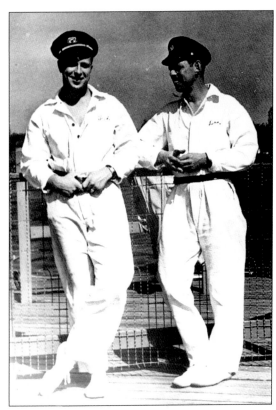

Fred Pearce Jr. (pictured at left), with Granger "Doc" Mason are seen here at Walled Lake in 1935 or 1936.

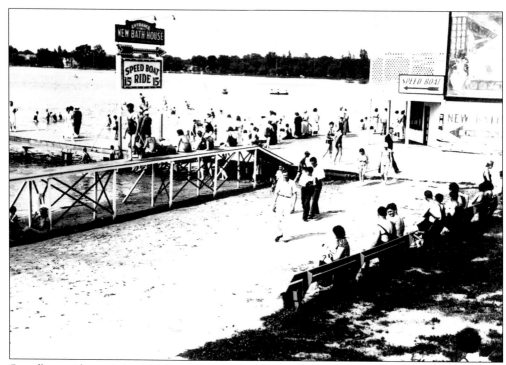

Speedboat rides on the lake became another form of amusement offered by the park and casino.

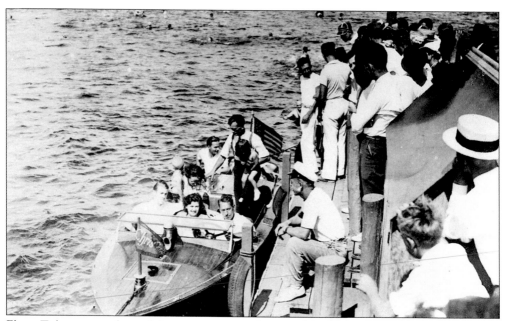

Elmer Tolettene, nephew of the owner, managed many of the boat rides.

After Louis Tolettene died in 1936, the casino was left to his wife, Leona.

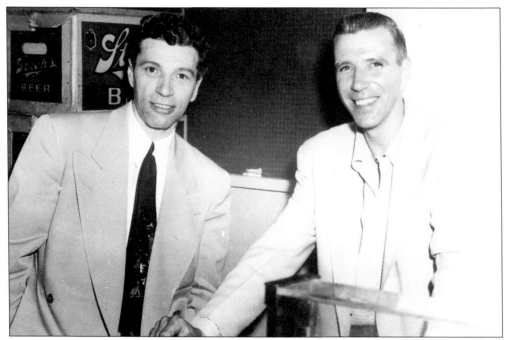

Leona turned it over to her nephews, Elmer and Elbert, to manage the business. Elmer (right) remained manager from 1946 to 1960.

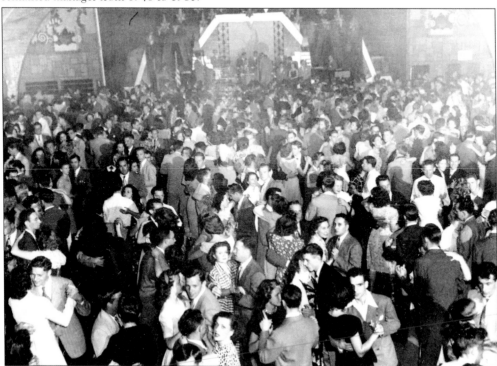

The Casino closed during the war years of 1941 to 1945, and when it opened again in 1946, the Tolettene boys brought the Big Bands to Walled Lake. Musicians such as Tommy Dorsey, Glenn Miller, Louis Armstrong, and more entertained nightly at the casino ballroom.

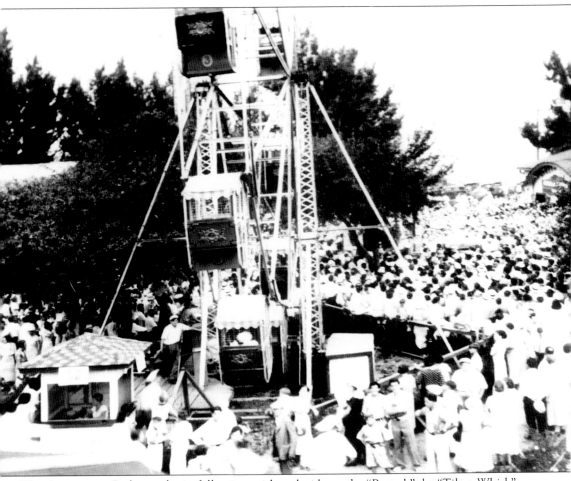

The Amusement Park was also in full swing, with such rides as the "Pretzel," the "Tilt-a-Whirl," and "Flying Scooters." Thousands of people continued to pour into the park regularly, making the name Walled Lake synonymous with fun.

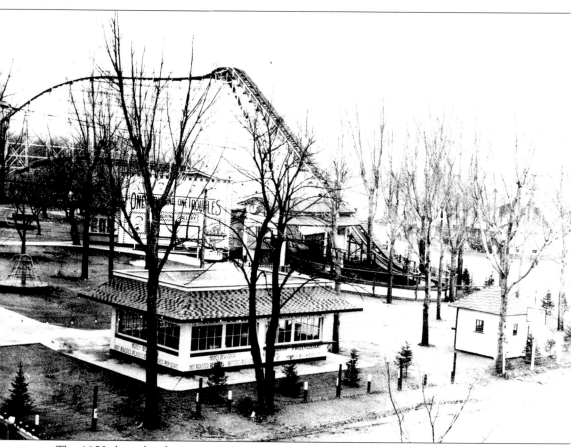

The 1950s brought about many changes. Due to dwindling attendance in the late 1950s, the Walled Lake Amusement Park finally closed its doors in 1968. Many of the rides were moved to parks within the city of Detroit.

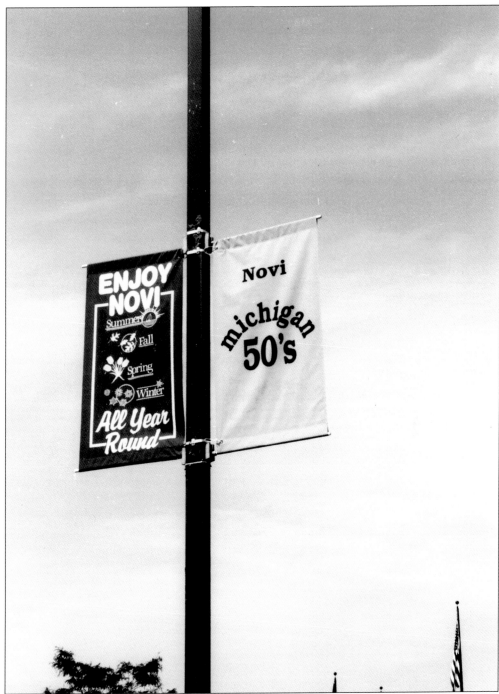

Though the Walled Lake Amusement Park exists no more, fun continues in the city of Novi, with its annual Michigan '50s Festival in July.

The Michigan '50s Festival is an annual summer event in Novi. Begun in 1987, it has grown to become the third largest annual festival in the state.

The elegant ballrooms of Walled Lake Casino may be gone, but today's dancers do not seem to mind.

120

While not as extensive, nor permanent like the amusement park of old, today's festivals provide almost as many thrills as their earlier counterpart.

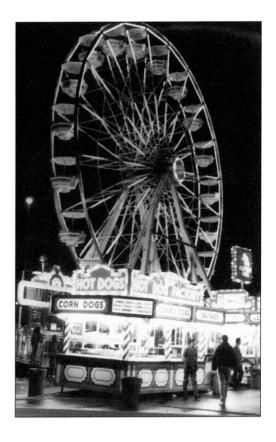

Nostalgia for what has been is an important part of the '50s Festival.

The last of the one-room schoolhouses still stands at Meadowbrook and Thirteen Mile Roads. It was converted to a house in recent years.

Eight

FOURTEEN MILE ROAD
. . . AND BEYOND

Novi's northern border lies on Fourteen Mile Road, just south of Commerce Township. The boundaries for Novi were determined when it attained cityhood in 1969, but Novi Township had actually extended farther than current city lines.

When Ford Motor Company decided to build its Lincoln-Mercury Plant along Wixom Road in what was then Novi Township, the community looked forward to what would surely be a boom to the town. (Courtesy Burton Historical Collection of the Detroit Public Library.)

This turned out to be just the incentive that the unincorporated community of Wixom, located just west of Novi's limits, needed in order to apply for incorporation as a village. In doing so, the location of the highly prized industrial plant is now part of Wixom. In March 1958, Novi became the largest village in Michigan; it became a city 11 years later.

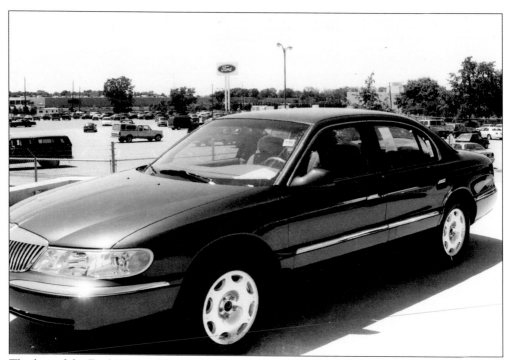

The loss of the Ford Wixom Plant was a blow to the new village of Novi. Fearing the loss of any more of their town, Novi citizens voted in 1968 in favor of city incorporation.

Until well into the 1950s, Novi was still the sleepy, slow-growing small town it had been for most of its life. The main factor that was probably more responsible for Novi's expansion than any other feature was the coming of the freeways. This view of a rest stop along Interstate 96 was taken just inside Novi's western city limits.

The on-ramp to Interstate 96 was still very much in the country shortly after its opening.

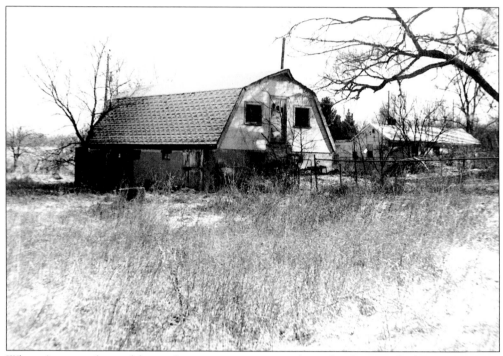

When America changed from a farming nation to an industrialized one in the late 1800s, Novi slowly changed with it. Barns like this one are rare, but still an important part of Novi's scene.

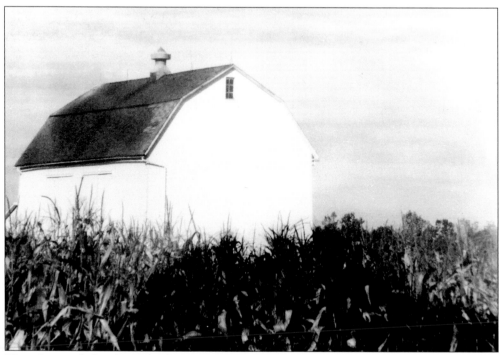

Though part of a bustling suburban center, Novi still has many current reminders of a time gone but not forgotten.

With the paving of roads in Novi, the look of the city changed quickly. To many residents it was a blessing; others regretted the passing of a slower, more leisurely way of life.

This picture of Novi from the 1960s portrays Novi in its changing stages from a rural farm community to a growing suburb.